GRANDMA MOSES

AN AMERICAN ORIGINAL

WILLIAM C. KETCHUM, JR.

TODTRI

This book was designed and produced by
TODTRI Book Publishers
P.O. Box 572
New York, NY 10116-0572
Fax : (212) 695-6984
e-mail : info@todtri.com

Printed and bound in Singapore

ISBN 1-880908-47-6
Visit us on the web!
www.todtri.com

Author: William C. Ketchum, Jr.

Producer: Robert Tod
Book Designer: Mark Weinberg
Production Coordinator: Heather Weigel
Project Editor: Edward Douglas
Editors: Linda Greer, Don Kennison
Picture Researcher: Ede Rothaus
Typesetting: Command-O, NYC

REFERENCES

Quotations from the publications listed below, copyright
©1947 (renewed 1975), 1952 (renewed 1980), 1969, 1973, 1982, Grandma Moses Properties Co., New York.

Kallir, Jane. *Grandma Moses: The Artist Behind the Myth.* New York: Clarkson N. Potter, Inc., 1982.
Kallir, Otto, ed. *Grandma Moses: American Primitive.* Garden City, N. Y.: Doubleday & Company, 1947.
Kallir, Otto, ed. *Art and Life of Grandma Moses.* New York: A. S. Barnes & Company, Inc., 1969.
Kallir, Otto. *Grandma Moses.* New York: Harry N. Abrams, Inc., 1973.
Moore, Clement C. *The Night Before Christmas.* Illustrated by Grandma Moses. New York: Random House, 1961.
Moses, Grandma. *My Life's History.* Edited by Otto Kallir. New York: Harper & Row, 1952.

CONTENTS

INTRODUCTION

The story of the American artist Anna Mary Robertson Moses—popularly known as Grandma Moses—is in a very real sense the story of twentieth-century folk art, that strange and controversial artistic field whose practitioners defy categorization while their works are alternately embraced and despised by both critics and public.

Moses was by no means the first American folk artist but she is unquestionably the most widely known, something I quickly became aware of some years ago when I curated a Japanese tour of the exhibition, "Through a Woman's Eyes: Female Folk Artists of 20th Century America" (Tokyo, Osaka, Sapporo, 1988). Though the ten women selected for inclusion were all well thought of here, I discovered that my Japanese colleagues privately referred to the group as "Grandma Moses and the Nine Dwarfs," an allusion to the overwhelming dominance, in their eyes, of Moses' work.

In all fairness, it is little different in the United States. The average citizen, if at all conversant with art history, knows Grandma Moses as he or she knows Rembrandt, Picasso, or Norman Rockwell. Yet Moses was neither the first of those termed folk artists nor, in the eyes of many, the greatest. How did she come to be so revered? The answer would appear to lie in a combination of factors: the nature of the field, the personality of the artist, and timing, which we all know is everything.

The field of folk art or, alternatively, self-taught or non-academic art, is largely an artificial construct created for their own benefit by collectors, dealers, and art historians. From the beginning of American history there were artists who were trained at the schools or academies which taught and perpetuated the technical skills and artistic concepts of American culture.

There were also, however, those outside the academies who catered to that large portion of the public who could not afford the services of the elite. Largely self-taught, often trained in allied fields such as sign painting, wall painting, or

May: Making Soap, Washing Sheep *detail; 1945.*
Moses often employed roads or fence lines to hold her paintings together; in this case a broad country path which links the sheep dipping pond with the distant rolling hills.

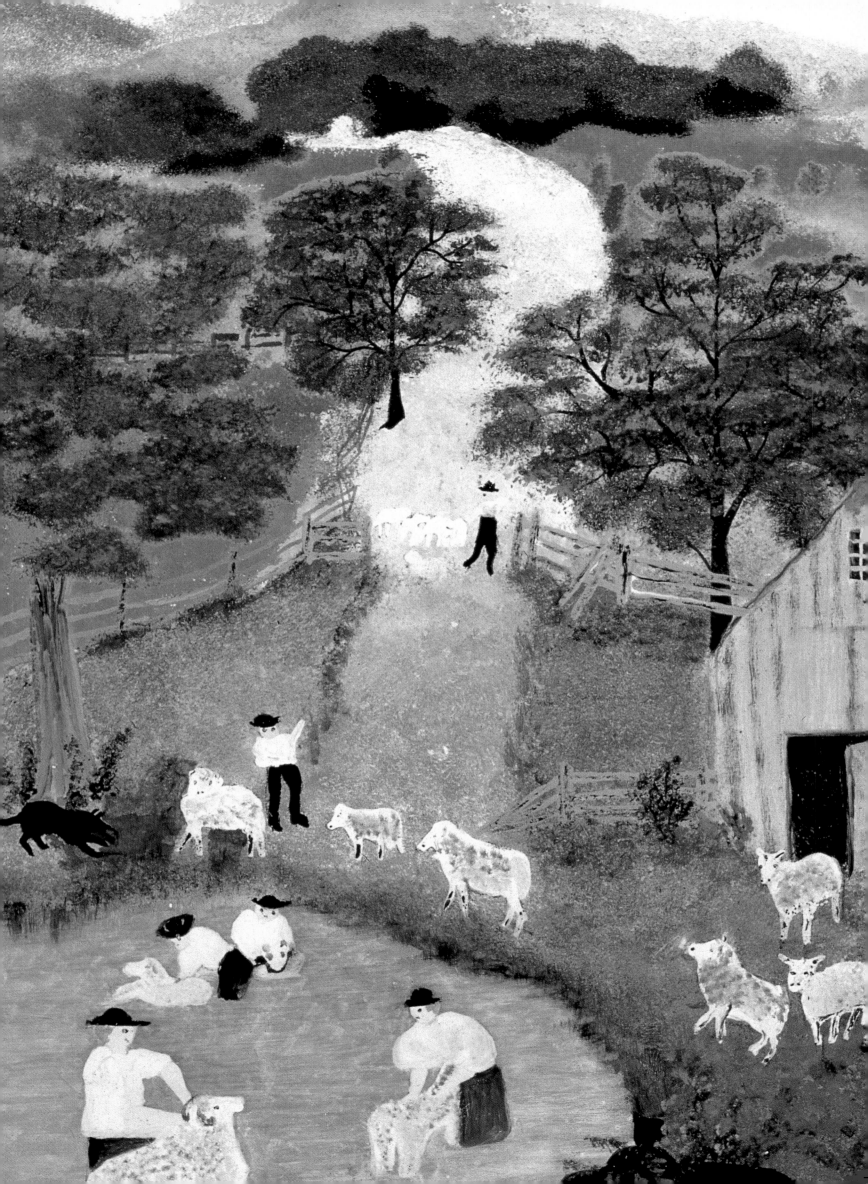

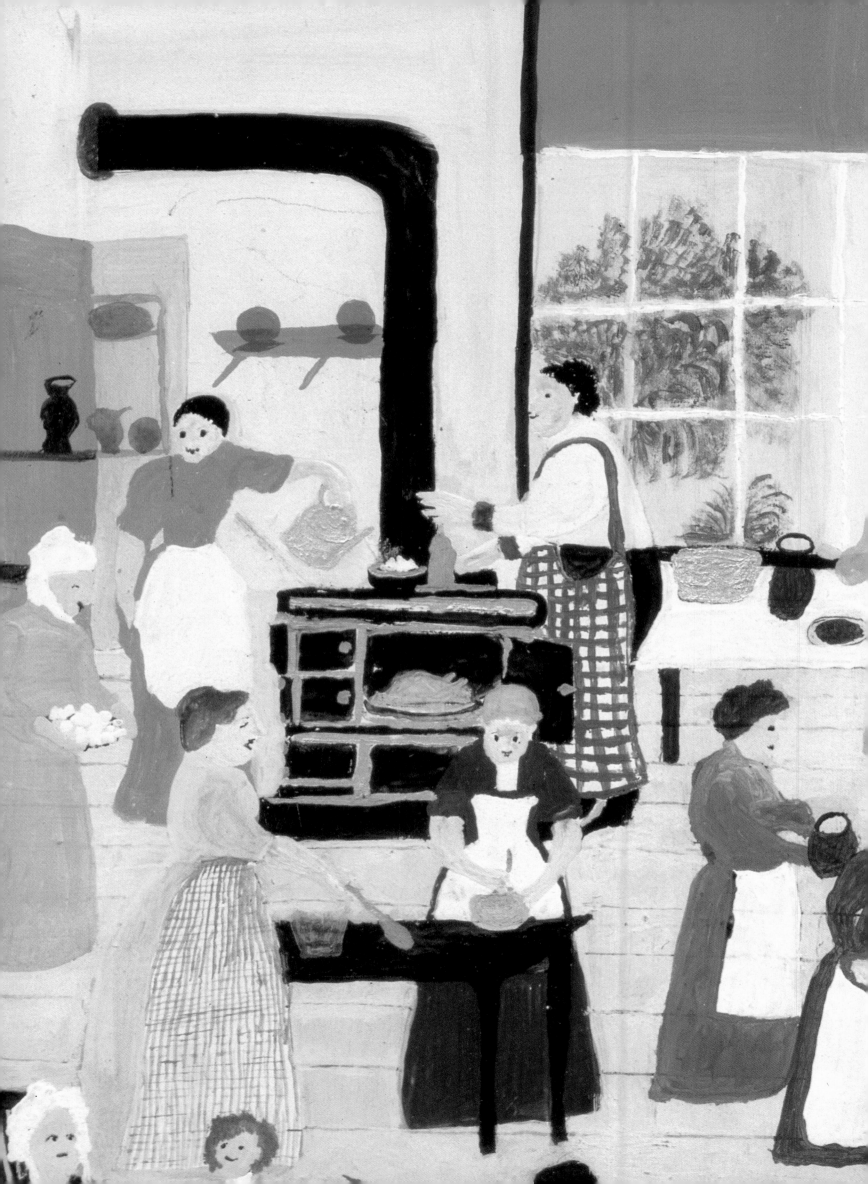

coach painting, but desirous of mimicking grander works (a preference obviously shared by their customers), these craftsmen employed as their learning tools contemporary artists' guides, prints, and whatever other materials came their way. When the opportunity presented itself, they also took lessons with the academically trained.

Though the work they did varied greatly in quality, these artists had one thing in common: they were professionals, at least in the sense that they made art for a living. Some traveled widely (hence the term itinerant artist), setting up temporary studios in farmhouses or taverns, advertising in local papers, and remaining in one spot only until the portrait- or landscape-painting business petered out. Others, especially those based in a large city with a wide customer base, tended to stay put. In either case painting was a job, with income often supplemented by painting a sign or a barn or farming a plot of land.

There were also those, often derisively referred to as "Sunday painters," who worked for pleasure rather than profit. Their art, too, mimicked that of the upper classes who could afford lessons and fine materials, and they frequently based their work on available examples of "high art," such as English engravings, prints, and at a later date, American lithographs.

In the early twentieth century the first American collectors of what was then referred to as "primitive paintings" were drawn primarily to the work of professional self-taught artists like William Matthew Prior (1806–1873) and Edward Hicks (1780–1849). Their compositions had a harsh American reality that seemed fresh and distinct when set against traditional European examples, despite the fact that Hicks' "Peaceable Kingdom" paintings were based on academic prints, and that Prior was skilled enough to produce a reasonable facsimile of an academic portrait—if the client would pay for it. Otherwise, the art buyer got the two-dollar "shade" or silhouette.

What the early collectors did not want was the work of the Sunday painters, the artistically unemployed as it were. Nor were they much interested in anything produced after about 1850, the year that early critics loudly proclaimed as a termination point for the folk art era, its demise brought about, they proposed, by industrialization and the development of the camera.

They were wrong, naturally. While the professional self-taught artist was forced from the field by social and economic changes, the Sunday painter remained. People who loved to paint, particularly women with their long tradition of textile pictures, theorems, and watercolors, continued to work. The difference—and it is a critical one in the field of twentieth-century folk art—is that few of these emerging artists hoped to earn a living by their painting.

Indeed, unlike most nineteenth-century practitioners who usually entered the field at a young

The Quilting Bee *detail; 1950.*
Though she spent a great deal of time there, Grandma Moses rarely painted kitchen scenes. In this one she pictures women going about the tasks that made possible the great family and community events around which country social life centered.

Following page:
Catching The Turkey
1940; oil on pressed wood; 18 x 24 in. (30 x 41 cm).
With three birds down and another under close pursuit, *Catching the Turkey* brings the Thanksgiving ritual to its frenzied climax. Details such as the bloody chopping block and the woman plucking feathers are unusual.

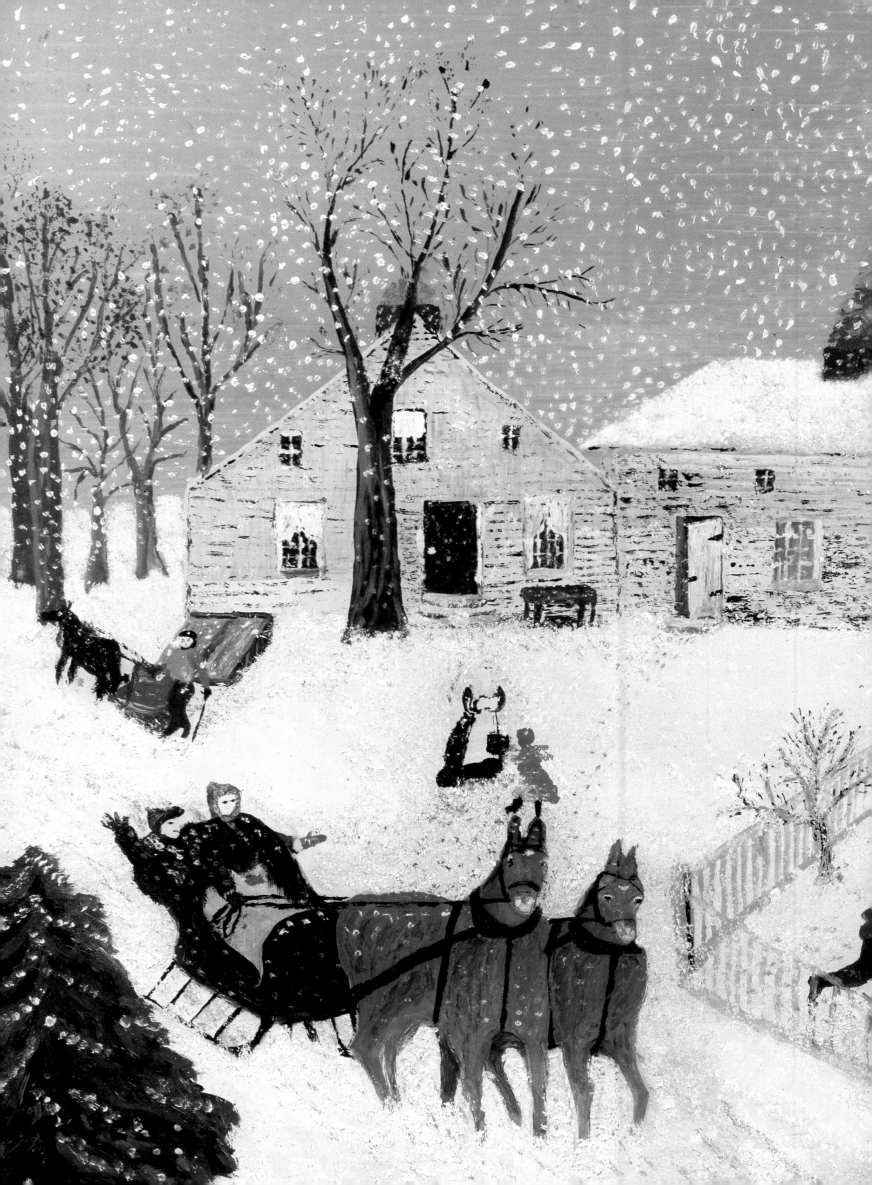

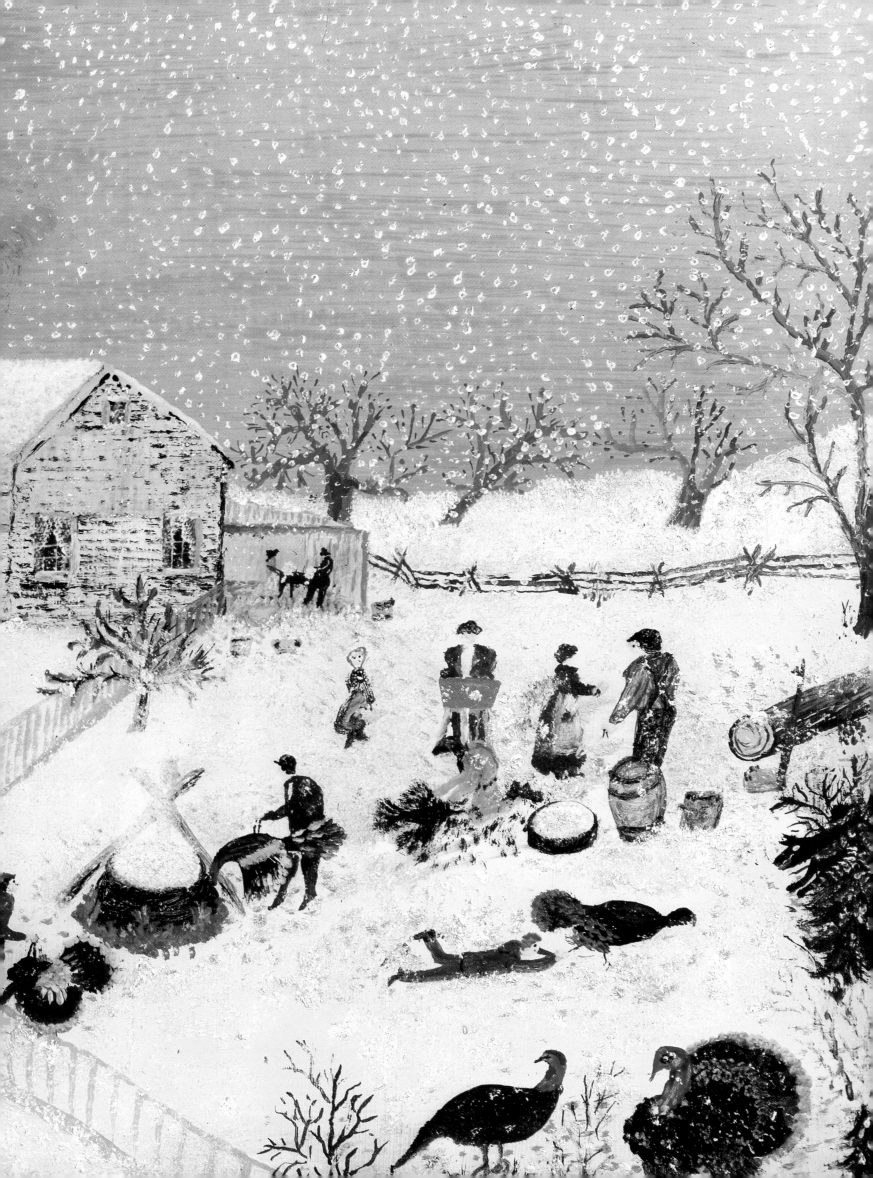

age, these artists tended to begin to paint rather late in life and, in many cases, were those whom we now refer to as senior citizens. Grandma Moses was a stellar example. Though she had dabbled in the field of art off and on in her life, it was only after the burdens of child care and farm management had been lifted that she began to paint in earnest. By this time she was in her seventies. Astonishingly, the apex of her career covered the last two decades of her long life.

She was not, however, the first twentieth-century nonacademic artist to attract critical attention. Major figures like John Kane (1870–1934), Joseph Pickett (1848–1918), and Horace Pippin (1888–1946) were already in the field when Moses' works began to appear in galleries. The fact that most of these artists died in relative obscurity and earned little by their art while Grandma Moses became a national icon has as much to do with her personality as with her paintings.

Anna Mary Robertson Moses can be seen as the quintessential American mother figure, our slimmed-down version of the Venus of Willendorf, and she arrived on the scene at a most opportune time. By the 1940s Americans were reeling from the effects of a prolonged financial depression and filled with dread of the rising fascism in Europe. The very principles on which the nation had been founded were cast in doubt. In this time of tribulation there emerged an artist whose work embodied everything that seemed good about America.

Moses painted scenes of the farms and small towns that were then either the present or the near past for many citizens. She proclaimed the virtues of family, church, community, and nation at a moment when these were under attack from without and within, and she lived these virtues. Her basic honesty, generosity, and good-heartedness shined forth both in her life and in her art.

That she was, in turn, attacked by certain critics and members of an emerging academic artistic community whose abstract work was unreadable (and whose politics and lifestyles were unacceptable) to the vast majority of Americans simply assured her success. But there was more; Moses was not a poseur, she was absolutely what she was: a simple country housewife. When her paintings began to sell for sizable sums and she became the first artist whose work was routinely licensed for such products as greetings cards, textiles, and the like, many people only wished her well.

That both the work and legend of Grandma Moses endures here as well as in Europe and Asia reflects not only the quality of her art but also the fact that she remains a symbol for many Americans of all that is good about their nation.

Christmas at Home *detail; 1946.*
As the mother of a substantial family, Grandma had an understandable fondness for children, and she painted them in all their exuberance and abandonment as in this Christmas scene.

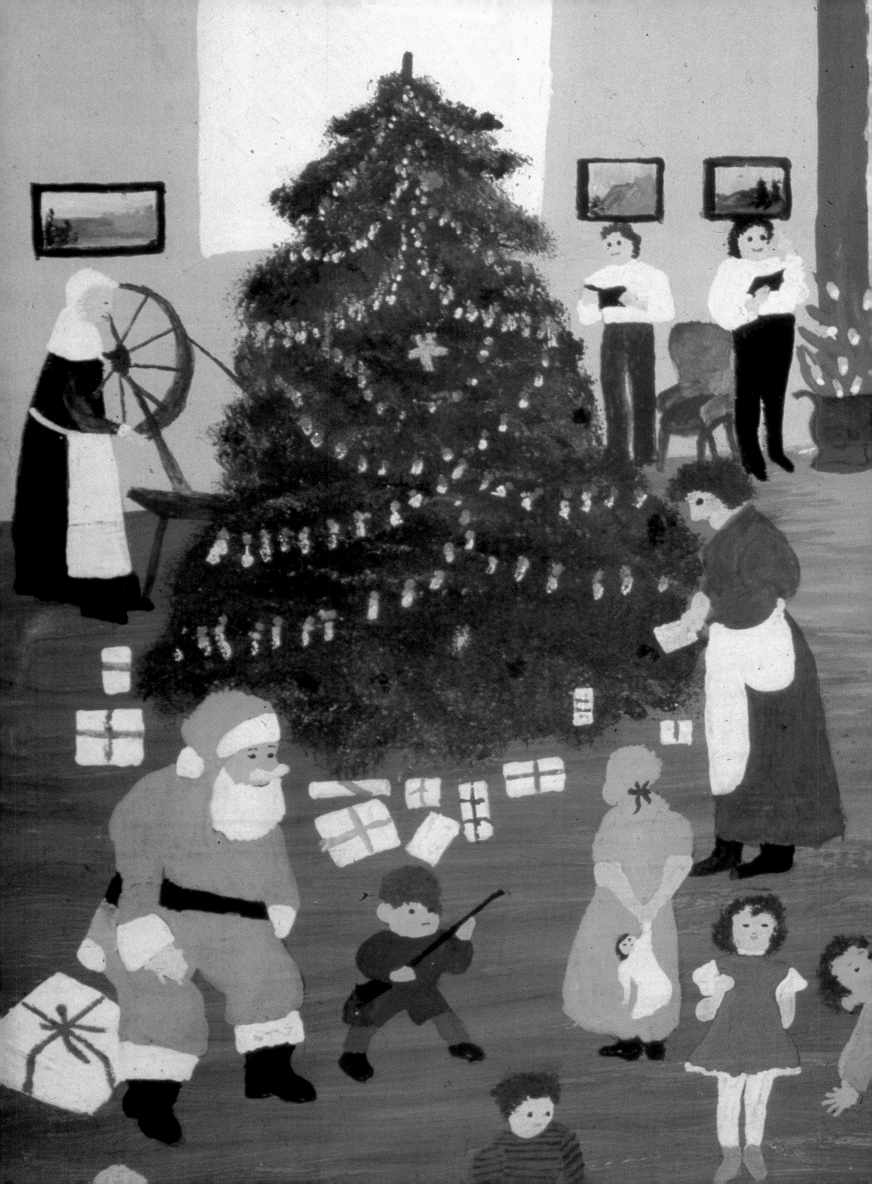

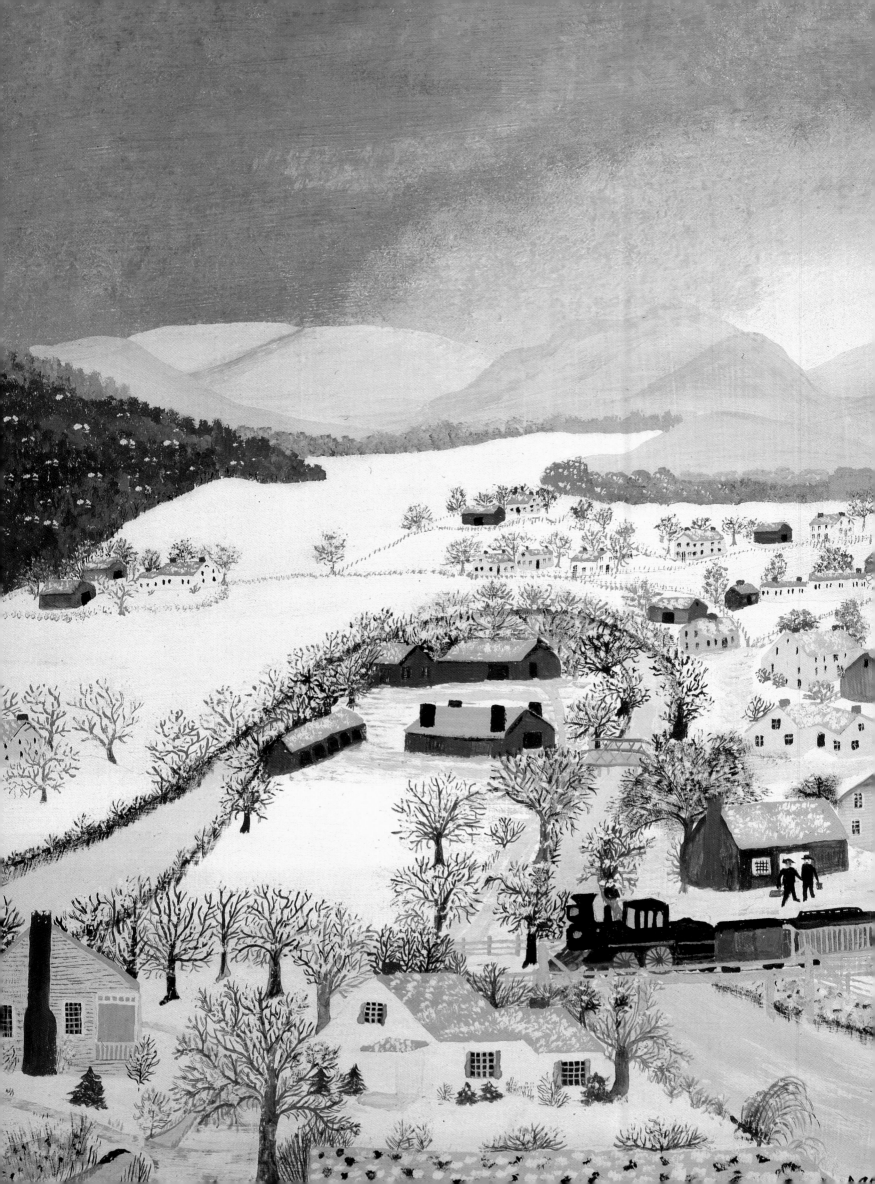

AN ARTIST'S LIFE

*I*f the dictum stating that artists tend to create from a store of personal history is valid, it should follow that the self-taught artist, lacking experience of academic technique and exposure to current styles, creates solely from the uncorrupted heart. There can be little doubt that the work of Grandma Moses grew out of her life history. She documented the ways she knew and the places she lived; an understanding of her life, remarkable for its longevity (spanning over one hundred years of American history), is essential to an understanding of her art.

Grandma Moses was born Anna Mary Robertson in Greenwich, Washington County, New York, on September 7, 1860. Her parents, Mary Shannahan and Russell King Robertson, were farmers but her father had some artistic talent. An oil on canvas landscape from his hand, now at the Bennington Museum in Vermont, is done in an ethereal nineteenth-century style reminiscent of the work of Thomas Chambers. It would be interesting to know more of Robertson's artistic background; this painting shows a hand too sure and too sophisticated to have been that of a mere Sunday painter. Was he ever a professional sign, carriage, or wall painter? No one seems to know.

Hoosick Falls, New York, In Winter
1944; oil on pressed wood; 20 x 24 in. (51 x 61 cm).
The Phillips Collection, Washington, D.C. Hoosick Falls was an important market and mill town for the farmers of the surrounding valley. Here, it is also viewed as a rail junction connecting the community to the greater, outside world.

Greenwich, at the time Grandma Moses was born, was a thriving market town. There were several mills along the deep Battenkill Creek, and the usual artisans and various stores which serviced the surrounding farms and provided a marketplace for their products. Life in the rolling foothills and deep valleys was, by our standards, quite simple. The farmers worked land which had been cleared in the eighteenth century (an ancestor, Hezekiah King, had come into the country in the 1770s), growing crops and raising sheep and cattle. The men and boys toiled in the fields, while women and girls performed the household chores. As Moses noted in her autobiography *My Life's History*: "Life was sort of routine. Monday washday, Tuesday, ironing and mending, Wednesday baking and cleaning, Thursday sewing, Friday sewing and odd jobs, such as working in the garden or with flowers. . . . And thus it was from year to year." Routine it might have been, but hardly easy.

By the 1860s life was changing in the New England hill farms. The land, mostly stony, was wearing out. The gold rush of 1849 had taken many young men, and more went, never to return, off to fight in the Civil War. After that conflict came the opening of the western lands, an agricultural paradise the attractions of which drained the hill farms.

Waiting for Santa Claus
1960; oil on pressed wood;
12 x 16 in. (30 x 41 cm).
Another in Grandma Moses' series of holiday paintings, *Waiting for Santa Claus* depicts the sleeping children "...with dreams of sugar plums..." dancing through their heads.

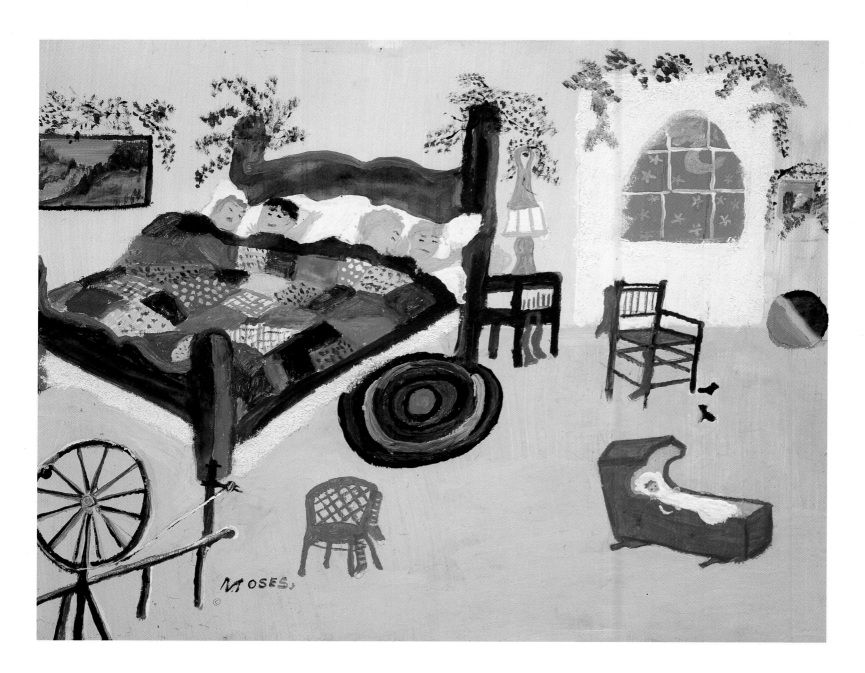

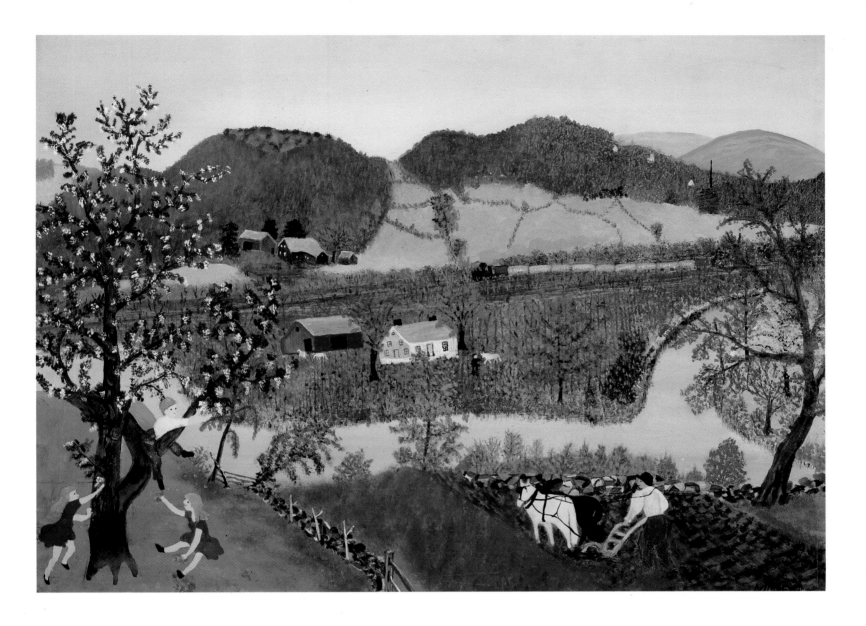

Life could not have been easy for those who remained behind, especially if, like the Robertsons, they had ten children. There was a need for extra income and a need for a reduction in the number of mouths to feed. In 1872 Grandma Moses, like many others, became a "hired girl," cooking, cleaning, and tending children for a family with more funds and fewer hands. During the early part of this period she acquired whatever "book learning" she could at the one-room country schoolhouses attended by her charges.

All this came to an end, though, on November 9, 1887, when she married Thomas Salmon Moses. The couple immediately left, not for the West, but for Virginia's Shenandoah Valley, where for several years they worked as tenant farmers.

Though she painted several Virginia scenes, Grandma Moses appears to have had little to say about her time in that great deep valley between the Appalachians and the Blue Ridge. Things must have gone fairly well financially, for after a while the couple bought a farm near Staunton; however, personal tragedy stalked the family. Between 1887 and 1905 the future artist bore ten children, half of whom died in infancy. While such infant death rates were not unusual for the period, the loss must still have been deeply felt. Yet no hint of this or any other hardship appears in Moses' work. True to the spirit of the memory painters, she described only the pleasant side of her life.

In any case, in 1905 the family, spurred by Thomas Moses' homesickness, returned to New York State, this time buying a farm at Eagle Bridge in Rensselaer County,

Hoosick River, Summer
1952; oil on pressed wood;
18 x 24 in. (46 x 61 cm).
Moses' Hoosick Valley series chronicled the life of the valley in which she lived for most of her life, viewing it in all seasons and all weather conditions; here in the lushness of full summer.

about fifteen miles southeast of Greenwich. This was the Hoosick River valley, an area not unlike the one Anna Mary had grown up in. Here, in an early-nineteenth-century house which she dubbed Mt. Nebo after a biblical peak, Moses lived until she moved into a more modern house nearby in 1949.

It was here, too, that the artist emerged. Like most children, Anna Mary had drawn and painted in school. Nothing exists from this period, but in 1918 she used housepaint on paper to decorate a fireboard (a board placed over a fireplace opening during the months it was

not in use). This piece, fortunately rediscovered beneath several coats of wallpaper, shows a similarity in style to her father's work. There were, no doubt, other attempts: she decorated an early chair or "tip up" table around 1920, but family matters were more pressing. In 1909 her mother and father died and, in January 1927 her husband passed away. Moses was sixty-seven years old. For most people life would be at an end; for her it was only beginning.

After spending the period from 1932 to 1935 in Bennington, Vermont, caring for a sick daughter and her

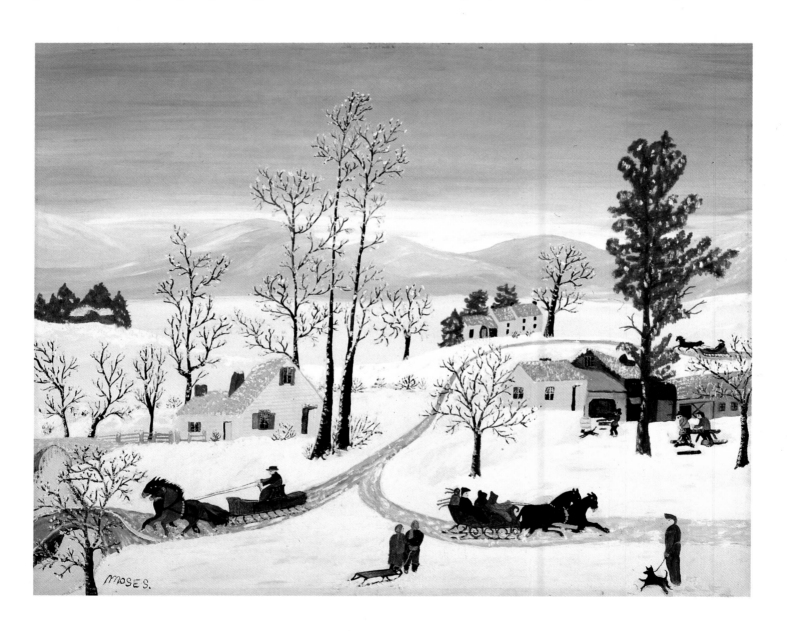

The Dividing of the Ways
1947; oil on pressed wood; 16 x 20 in. (41 x 51 cm).
Museum of American Folk Art, New York City. On a cold winter day children watch as two sleighs diverge at a crossroad, the passengers in each intent on their journey.

children, Anna Mary returned to Eagle Bridge and continued to do needlework pictures, as she had in Bennington, switching later to oils. She exhibited these at the Washington and Rensselaer county fairs, church sales, and wherever else a venue might be found. By 1938 this included the Thomas drugstore in Hoosick Falls, a sizable factory town about five miles south of Eagle Bridge. It was there that she was, in art-world argot, "discovered."

Louis J. Caldor, a civil engineer by profession and art collector by avocation, chanced upon the drugstore display and purchased a dozen or so of the small pictures. So excited was he by the work that he eventually tracked Moses down at the Eagle Bridge farm, where she had been quietly raising chickens and grandchildren. Caldor encouraged Moses, provided her with professional materials, and tried diligently to market her work. He appears to have been both a discerning judge of artistic talent and a man of remarkable character who, unlike so many current dealers and agents for nonacademic artists, neither patronized nor attempted to take advantage of his naive charge.

Caldor's efforts bore their first fruit in the fall of 1939, when three of Grandma Moses' paintings were included in an exhibit, "Contemporary Unknown American Painters," at the Museum of Modern Art in New York City. Though nothing much came of this

Night is Coming

1942; oil & tempera on pressed wood;
8 x 10 in. (20 x 25 cm).

This brooding snowscape is somewhat atypical of Moses' work. Not a creature stirs on the darkening landscape, and the only sign of humanity is the thin stream of smoke from the cottage chimney.

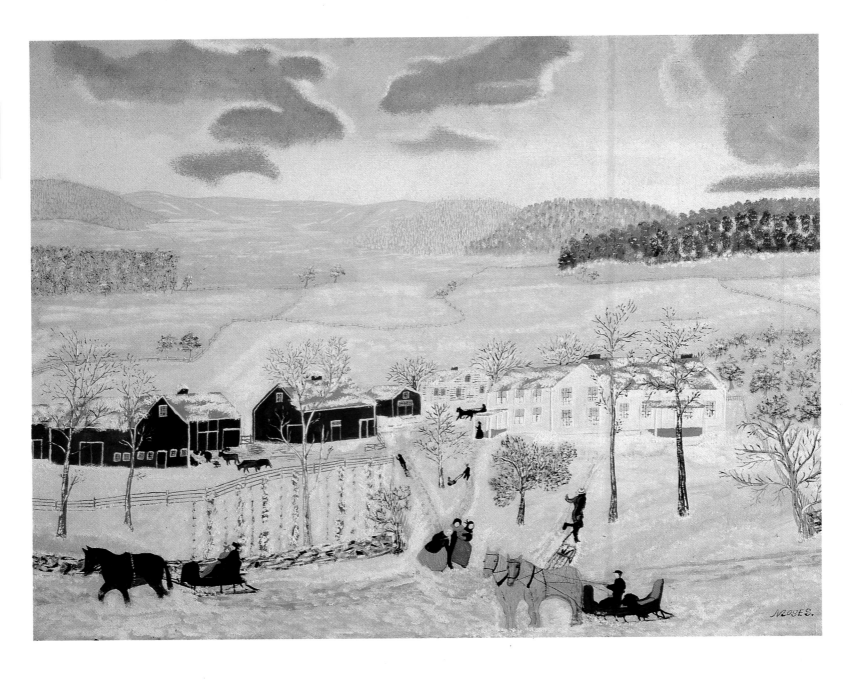

Mt. Nebo in Winter

1943; oil on pressed wood;
20 x 26 in. (51 x 66 cm).
Yet another view of the Moses family
farm, this time in the dead of winter
when transportation is by sleigh and
any visitor is a most welcome one.

initial effort, it encouraged Caldor, who then sought out Otto Kallir, an Austrian immigrant and the owner of Galerie St. Etienne, a Manhattan showcase for the work of the Austrian modernist movement. Kallir, too, was taken with the artist's work; he quickly arranged a one-woman show—"What a Farm Wife Painted"—held in October of 1940.

Though it would hardly be accurate to say that Anna Mary's career now took off, this show clearly set it on its way. There were favorable newspaper reviews, inclusion at other venues, and an exhibition at Gimbel's department store at which the artist made her first New York City appearance, to all accounts charming the jaded metropolitan audience. Kallir worked untiringly on her behalf from then on, launching numerous traveling exhibitions throughout the United States. To a great extent, though, the Moses phenomenon represented a combination of the artist, her work, and the times in which she thrived. And these were generally bad times.

Grandma Moses came to public notice at the end of the Great Depression, the most devastating economic recession our nation had ever known and one resolved only by Pearl Harbor and the draining war that followed. The fabric of American life had been sundered. In a country where agriculture was thought of as a noble pursuit and the

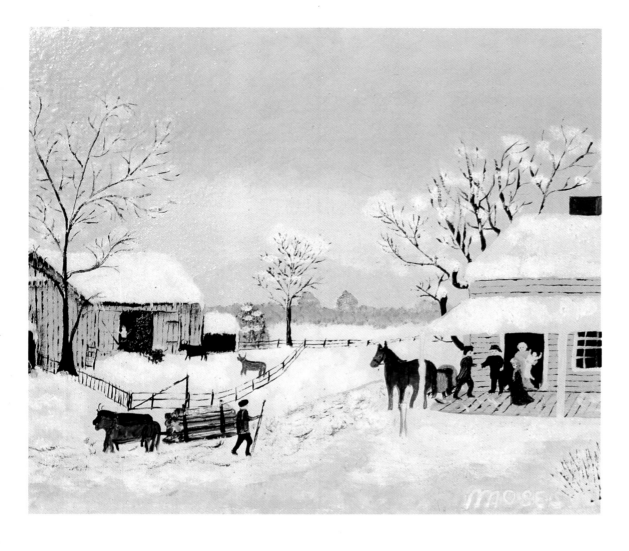

Home for Thanksgiving
1942; oil on pressed wood;
8 x 9 3/4 in. (20 x 24 cm).
Though this painting of the
Thanksgiving homecoming
is based on the well-known
Currier & Ives lithograph,
Moses has rearranged the
elements and altered the
composition to create
her own, unique rendition.

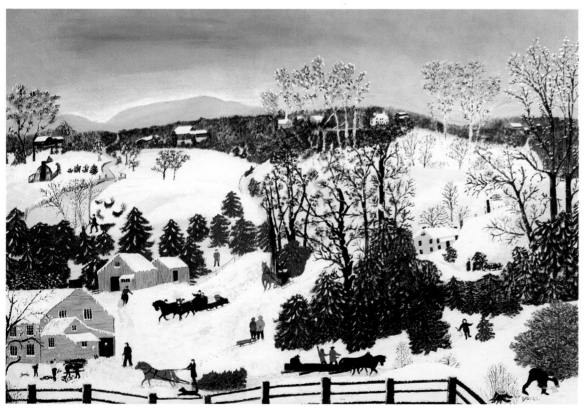

Out for Christmas Trees
1946; oil on pressed wood;
26 x 36 in. (66 x 91 cm).
In Grandma Moses' time,
as it often is even today in
the country, the traditional
Christmas tree was cut from the
surrounding woods rather than
purchased. Finding a suitable
tree was itself a festive event.

farmer idealized, midwestern agriculturalists were driven from the land by dust storms and bank foreclosures. Hundreds of thousands more abandoned the earth for wartime factory jobs. Yet the dream of a rural life persisted, and the art of Grandma Moses evoked it most strongly.

Moses' work was simple, direct, and honest. Only a tiny portion of the American audience of the time under-

stood or even tolerated twentieth-century artistic styles, especially the Abstract Expressionism which came to dominate the field after World War II. For these people the art of Grandma Moses expressed a better, though lost, America in a literal, comprehensible manner.

The artist herself must also be considered. She was so clearly the genuine article, practically immune to the virus of fame and self-importance, and determined to

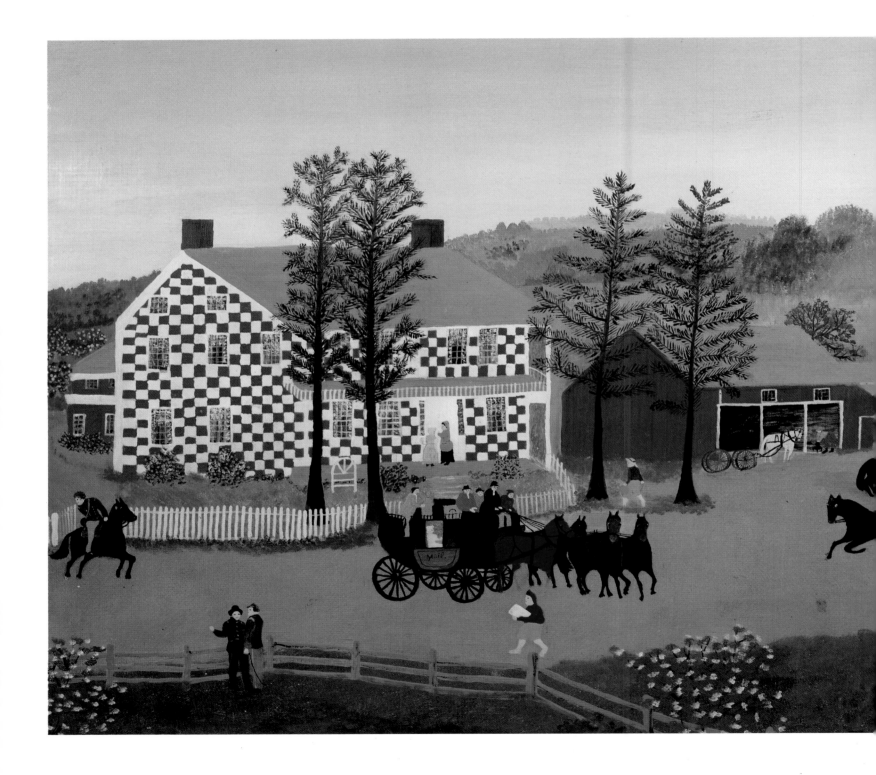

continue living just as she had before her unexpected fame. As she is quoted by Jane Kallir, Moses remarked to a reporter for the *New York World-Telegram* in 1940: "Well, people tell me they're proud to be seen on the street with me. . . . But I just say, well, why weren't you proud to be seen with me before? If people want to make a fuss over me, I just let 'em, but I was the same person before as I am now."

Another characteristic which endeared Moses to her broad audience was her view of art, one which she clearly shared with her public. She simply did not regard it as of great importance. She considered it primarily as a way of supplementing her farm income and as a pleasurable pastime. The concept of artistic angst and creative suffering was as laughable to her as it was to her fans. Moreover, it appears that she was baffled

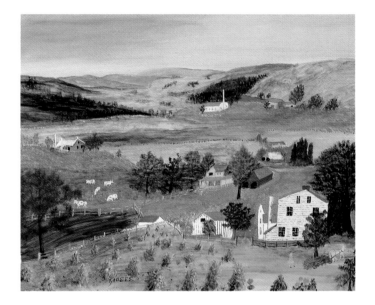

Ripe Pumpkins

1951; oil on pressed wood; 13 x 16 in. (33 x 41 cm).
The rich earth tones of the surrounding hills provide a fall background for the farm and a field in which orange pumpkins glow between stacks of cut corn.

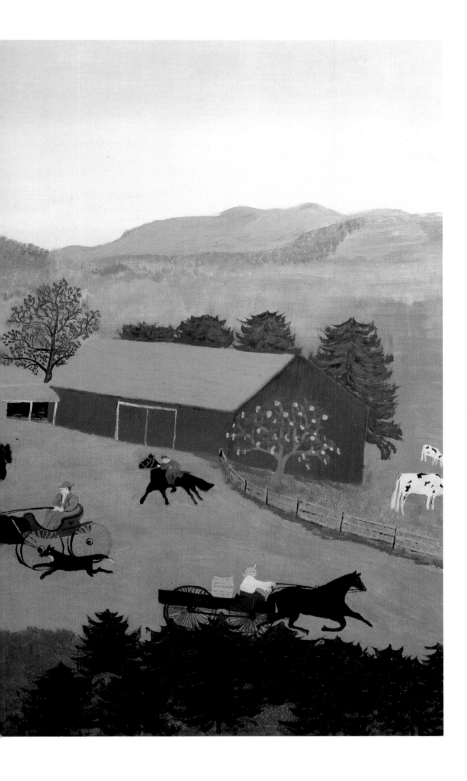

The Old Checkered House

1943; oil on pressed wood; 24 x 43 in. (58 x 109 cm).
Yasuda Kasai Museum, Tokyo. In this early-summer view of the famous hostelry it is seen as a stagecoach stop with a loaded coach about to depart, while horsemen, wagons, and a light gig hurry across the busy foreground.

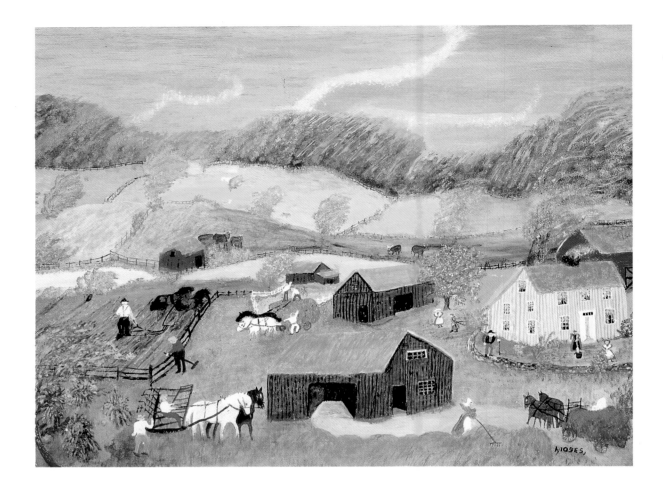

Wind Storm

1956; oil on pressed wood;
16 x 24 in. (41 x 61 cm).
A dramatic painting in
which the wind sweeps
across the canvas from
left to right, bowing the
trees and disrupting the
important task of getting
fall hay into the barns.

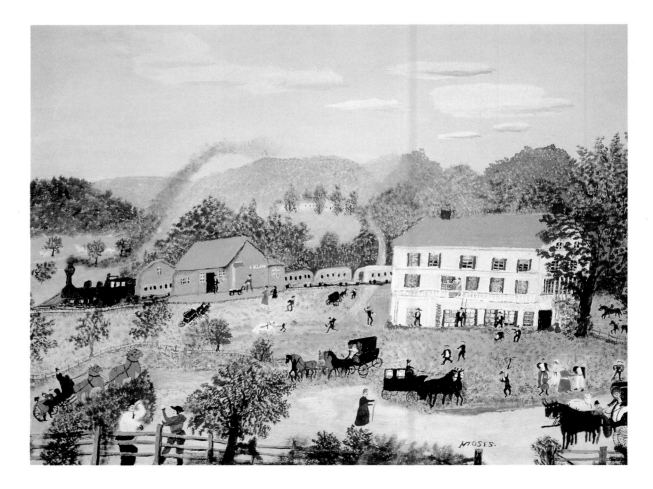

Eagle Bridge

1959; oil on pressed wood;
16 x 24 in. (41 x 61 cm).
Eagle Bridge was Moses'
hometown, and she
painted it many times.
Here she captures the
excitement of that mo-
ment when the daily
train pauses at the station
bringing visitors and news.

by the high prices her work brought.

Nevertheless, she continued to paint and her fame continued to grow. It is safe to say that no American artist, either academic or self-taught, has achieved the national popularity of Grandma Moses. She was honored by United States presidents from Harry Truman to John F. Kennedy, corresponded with Winston Churchill, saw her birthday twice proclaimed by Governor Rockefeller as "Grandma Moses Day" in New York State, and has been the subject of several books. Neither her death, on December 13, 1961, nor the proliferation of countless pseudo–memory artists has diminished the luster of her work. Americans and all art lovers still recognize the genuine article.

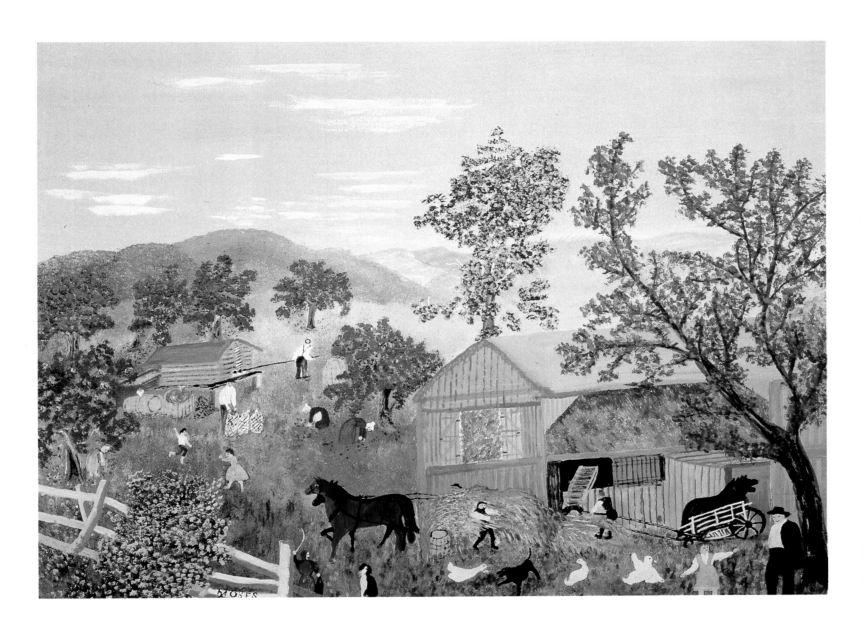

For This is the Fall of the Year
1947; oil on pressed wood; 16 x 21 3/4 in. (41 x 56 cm).
Moses' seasonal paintings faithfully record the traditional activities (here picking apples and putting in hay) that mark the turning of the year.

Following page:
The Old Bucket
1960; oil on pressed wood, 16 x 24 in. (41 x 61 cm).
In this summer version of the well-bucket paintings, several women are drawing water while being observed by the "watcher at the doorway" who appears in so many of Moses' works.

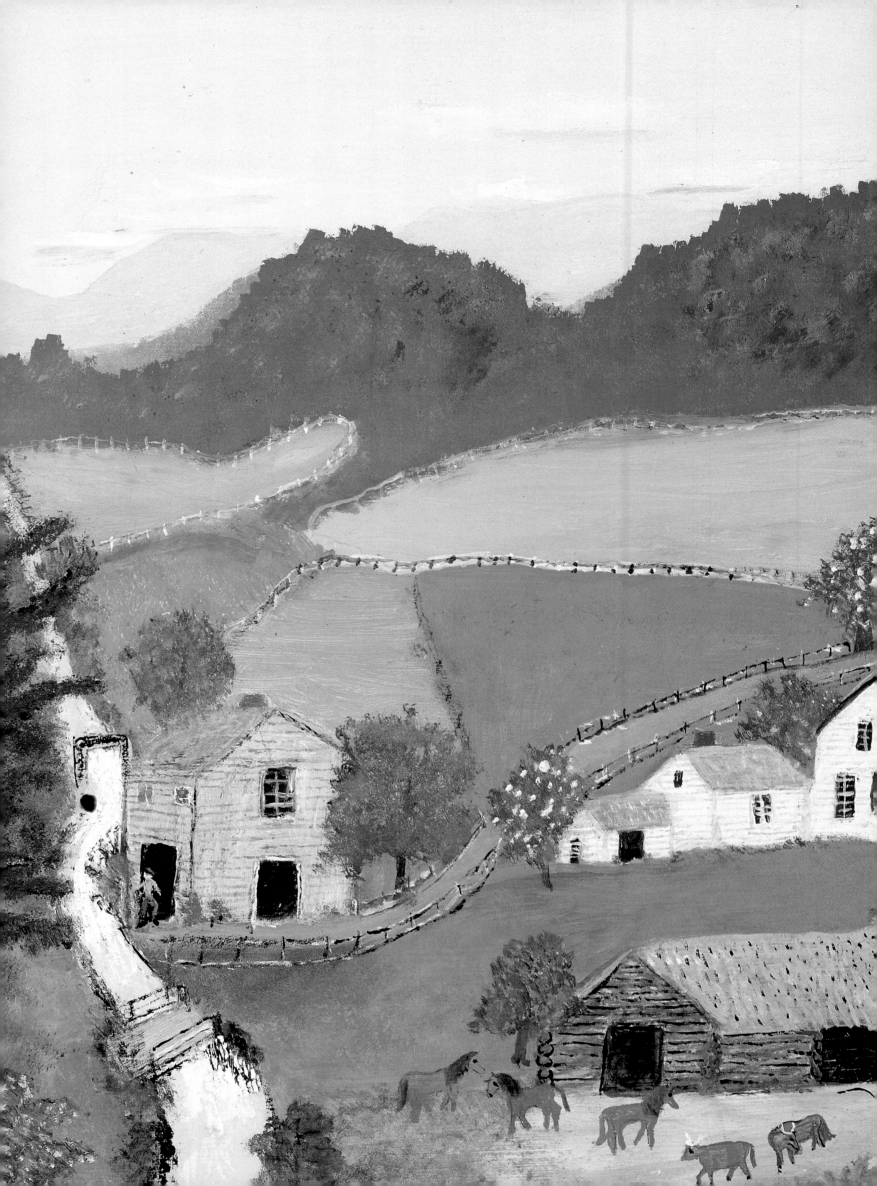

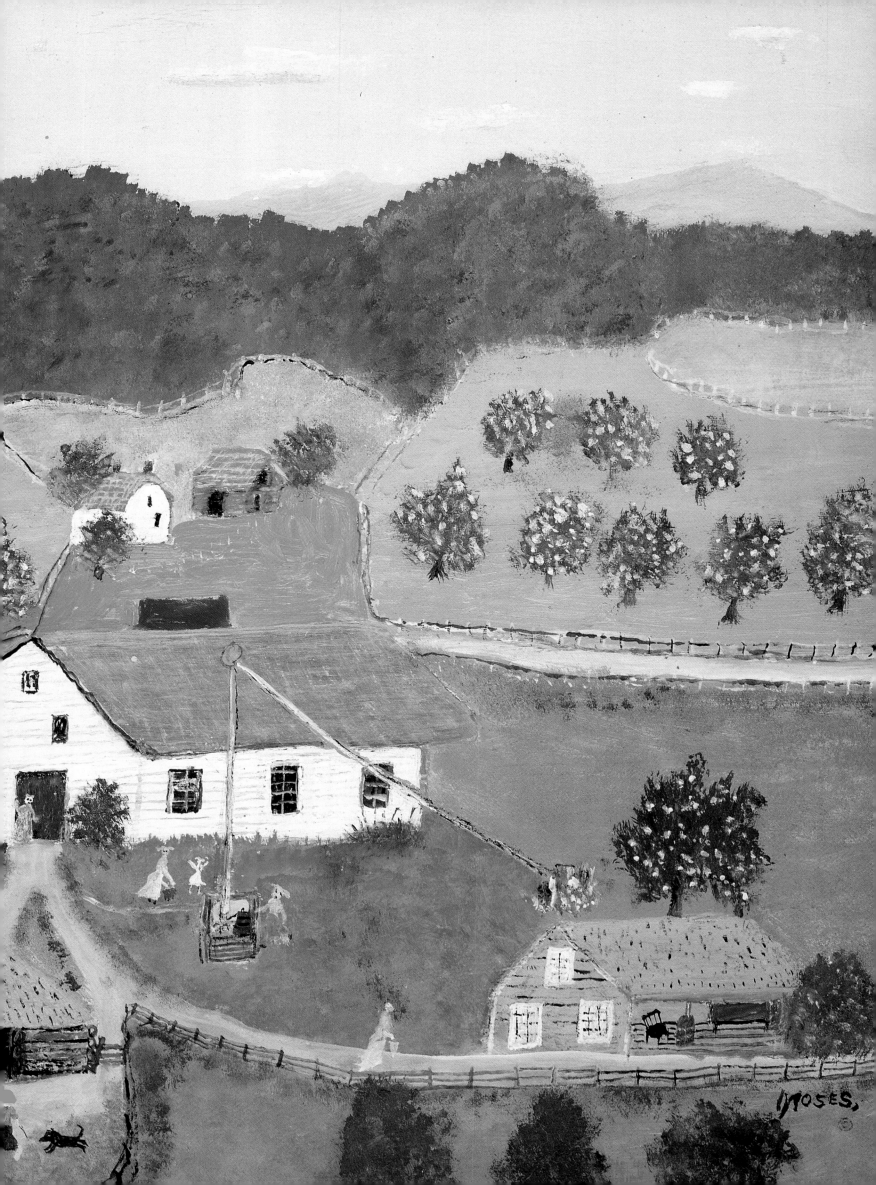

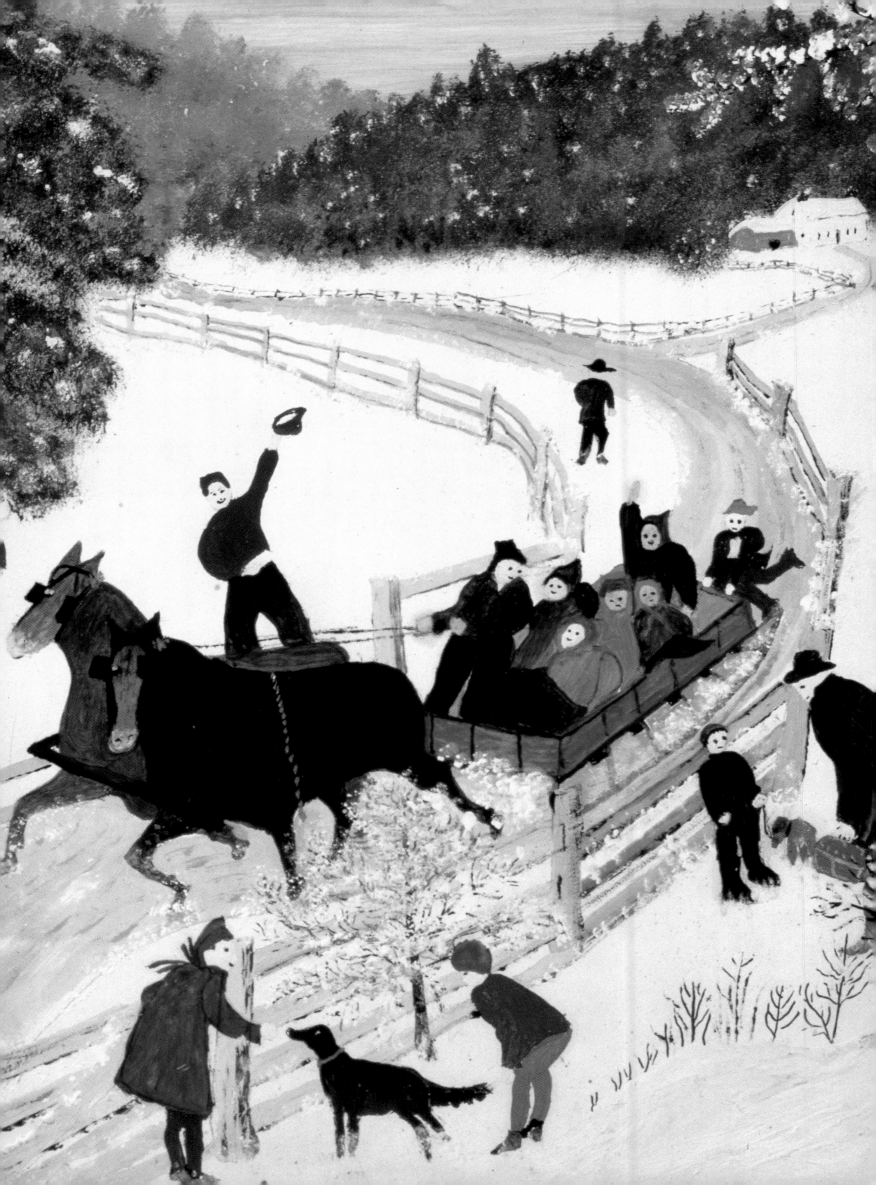

BEGINNINGS

Worsted Pictures

Though she worked in various mediums off and on over the course of several decades, Grandma Moses' first sustained artistic endeavors appear to date from the 1930s, and focusing on needlework rather than painting. This is not surprising given the fact that she grew up in an era where every girl learned to sew, knit, and crochet, and most could also hook rugs and piece quilts. On the other hand, the world of painting was largely closed to young women from the farming and artisan class. Both cost and the limited availability of instruction and materials made artistic training unlikely for them. Moses' remembrances of substituting small bits of wood for brushes and using paint sparingly in her early work reflects this situation.

Yarn, however, was readily available. Almost every farmer raised sheep and their wool, spun into yarn and dyed with natural or aniline dyes, provided a suitable medium for textile paintings. The artist would also have been exposed to the popular Berlin work textiles which were made by following a printed paper design, rather than being created more or less freehand as were early-nineteenth-century samplers and textile or mourning pictures.

Berlin work was done in wool instead of the silk thread favored in samplers; some of Moses' early work, such as *House and Flower Garden* (c. 1931), owes much to this medium. Moreover, the fact that the house, an English cottage, would have been quite inappropriate in the Hoosick Valley also indicates that the piece is based on either a print or a Berlin-work design. Much the same may be said of *When The Shepherds Come Home* (c. 1939), in which the English thatched cottage again appears, now alongside a body of water much larger than any to be found in the Hoosick Valley.

However, in *The Old Hoosick Bridge* (c. 1939), Moses begins to adapt the textile technique to her own purposes according to the topography of her own

The Old Hoosick Bridge
c. 1939; worsted embroidery;
10 x 14 in. (30 x 36 cm).
In this worsted picture Moses depicts an ancient covered bridge (erected in 1818) that spanned the Hoosick River. Once common in the Northeast, few of these remain today.

Joy Ride *detail; 1953.*
Moses lived, remembered, and visualized a period before automobiles and super highways when speed was represented by a horse-drawn sleigh flying down an icy dirt road, its progress marked by cheering boys and admiring elders.

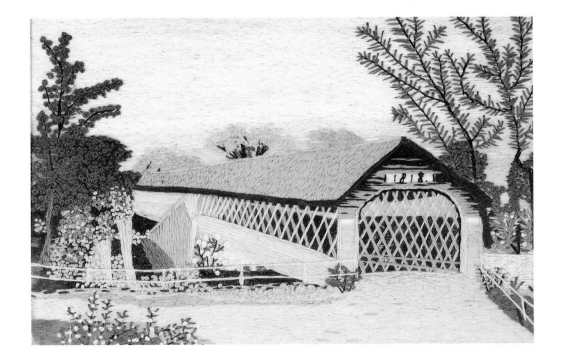

countryside. Covered bridges (covered to protect the wooden flooring, not passersby), while found elsewhere, are primarily an American phenomenon. Moreover, the landscape in this work begins to take on a more American regional appearance.

This trend is continued in *Autumn In The Berkshires* (c. 1939) and *The Roadside Garden* (c. 1939). In the former the rolling Berkshire hills provide a backdrop for the only building, a typical American center-hall colonial, before which appears a familiar farm wagon pulled by oxen. In *Roadside* the hills are seen again, now backing a traditional New England complex of home, barns, and outbuildings. These two works seem to foretell the technique of Moses' later oil paintings. Art historian Jane Kallir argues convincingly that the artist, more familiar with textiles than paints, attempted to use the latter in a way that would achieve the visual impact of the former.

Kallir notes that "She was inclined to apply pigment the same way she applied yarn: in broad smooth swaths, or short, stitchlike dabs. Experience with embroidery taught her to isolate blocks of color, to break forms into their

Mt. Nebo On The Hill

c. 1940; worsted embroidery;
10 x 14 in. (25 x 36 cm).
While much of Moses' early embroidery is based on prints (usually English) and has little to do with her own life, this example depicts the family farm in the Hoosick Valley.

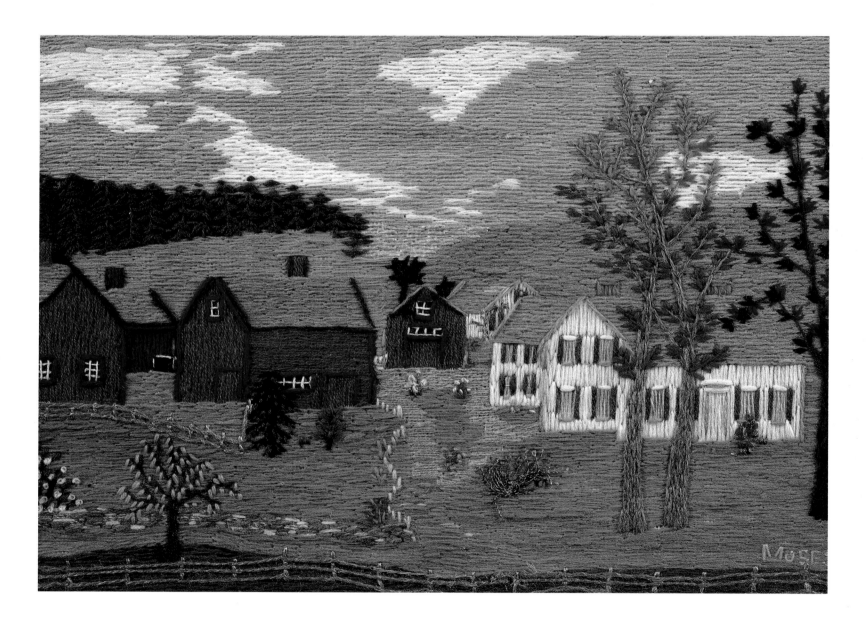

component hues." In short, you might say she became, in her own way, an Impressionist.

Kallir also suggests that this relationship between needlework and painting may be seen in Moses' composition, noting a "quiltlike quality," to the work. However, it is possible that it reflects also the artist's certain familiarity with hooked rugs, the floral patterning of which often provides a series of color waves not unlike those seen in Moses' landscape paintings. In any case, there is no doubt that throughout her career the work of Anna Mary Robertson Moses continued to be influenced by the various textiles which she and others around her had created.

The Shepherd Comes Home from the Hills
1939; worsted embroidery; 12 1/2 x 27 1/2 in. (32 x 70 cm). Like many of Moses' early worsted pictures, this one was adapted from a European print. Neither the house nor the topography is typical of her later work.

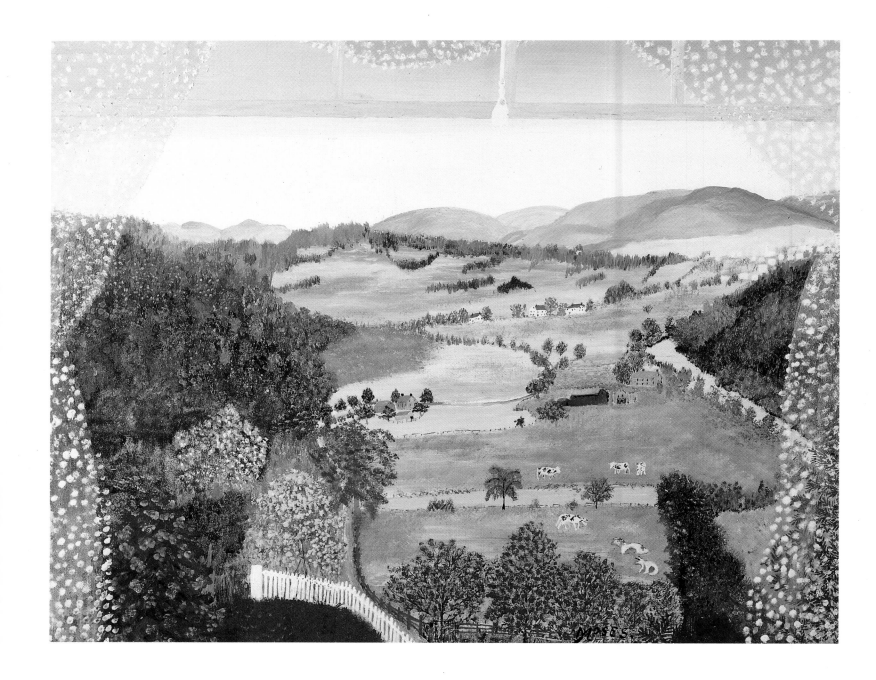

**Hoosick Valley
(From the Window)**
*1946; oil on pressed wood;
19 1/2 x 22 in. (51 x 56 cm).*
Moses frequently painted her
window view of the Hoosick River
valley; however, here she specifically
and uncharacteristically frames
the image with her lace curtains.

Painting Techniques

Unlike academic painters, whose endless discussions of technique have provided a living for bartenders and restaurant owners from the Left Bank to Greenwich Village, self-taught artists are notoriously unwilling or unable to find a vocabulary for their methods. Grandma Moses' response to the question, "How do you paint?" was typical. She began by noting that "before I start painting I get a frame, then I saw my masonite board to fit the frame." There follow several paragraphs about preparing the surface, cost of paints, etc., but not one word about how she produced her luminous landscapes.

However, Moses' methods have been well analyzed by Jane Kallir in her definitive *Grandma Moses: The Artist Behind The Myth*. Grandma Moses' subject matter was her life. Though she, like other artists, sometimes relied upon newspaper or magazine illustrations, Christmas cards, academic paintings, or period prints for inspiration, these served only as a sort of pictorial reference from which she constructed her original composition. For this reason, when called upon to paint multiple versions of a popular subject such as that of the

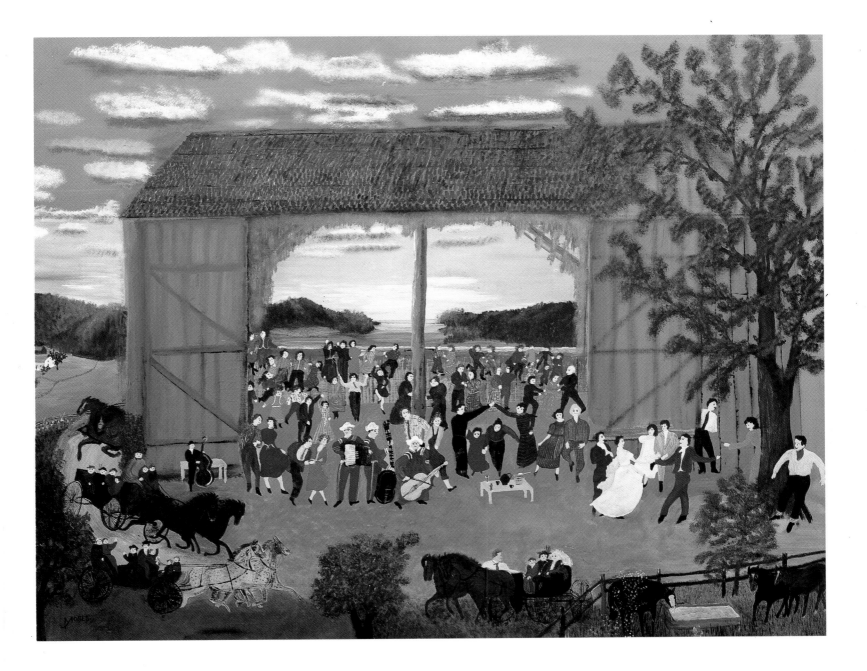

Old Oaken Bucket, she was always able to present a fresh perspective.

As she explained to Otto Kallir, she saw each subject as from a window—as illustrated literally by her lace curtain–framed *Hoosick Valley From The Window* (1946)—so simply by shifting her angle of vision she could offer an entirely new composition.

Moses was primarily a landscape artist. Even in her interiors she was always attempting to bring the outside in, as in *Husking Bee* (1951) and *The Barn Dance* (1950), where the doors of a drive-through barn are flung open to reveal a continuing landscape as a backdrop for interior activity. Some have reasoned that this preference for landscapes reflects the artist's difficulty in rendering human and animal figures, but Kallir argues persuasively that it is based more on the

The Barn Dance
1950; oil on canvas; 35 x 45 in. (89 x 114 cm).
A great social gathering, and one the young folks were especially fond of, was the barn dance. What with fiddling, dancing, and drinking, the party often went on until dawn.

Following page:
Country Fair *detail; 1950.*
With Grandma it's all in the details as may be seen with this extraordinary assemblage of transportation; horse-drawn vehicles of every imaginable sort, from gigs and sulkies to omnibuses more suitable to New York City than to Eagle Bridge or Hoosick Falls.

relationship between her needlework background (as seen in the early worsted embroideries) and her paintings.

As Kallir notes in her book,

> The constraints of working with yarn actually seem to have conditioned the artist's visual perceptions. Because embroidery does not allow the blending of colors or the modeling of form, she had to invent other solutions to these problems. She learned to build tonalities by layering or interspersing different hues. Details, such as figures, that did not lend themselves to such interpretations were simply rendered as flat shapes.

The result was highly patterned designs with fields of color sometimes resembling those found in the quilts and hooked rugs that the artist would have been most familiar with.

In time these patterns, based on the rolling hills, green valleys, and distant blue mountains Moses was so familiar with, became progressively more abstract, acquiring an impressionistic quality evident in Moses' finest work. However, she was never interested in the classical European landscape where man, if present, was always a minor observer of nature's bounty. Hers were instead backgrounds for human activity—farming, travel, work, and play; there is little doubt that the people and animals were a significant part of what drew most enthusiasts to her work.

Certain of these busy figures appear again and again in Moses' paintings. The pale figure of the woman waving from the doorway (*Joy Ride* [1953] and *Sugar Time* [1960]) and the man carrying sap buckets on a shoulder yoke (*Sugaring Off* [1943] and *Sugaring Off In Maple Orchard* [1940]) are but two of many familiar figures.

The Rainbow

1961; oil on pressed wood;
16 x 24 in. (41 x 61 cm).
The artist often used rainbows to good effect. However in this instance—her last finished work—the rainbow, faintly seen behind a group of leafy trees, serves only as a backdrop for a variety of late-summer activities.

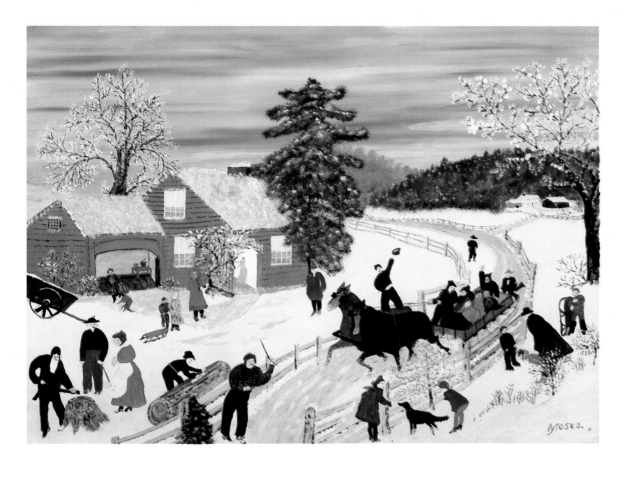

Joy Ride

1953; oil on pressed wood;
18 x 24 in. (46 x 61 cm).
Yet another scene of spontaneous country fun, this winter scene recalls the days when loaded sleighs raced each other along the narrow, snow-covered country roads.

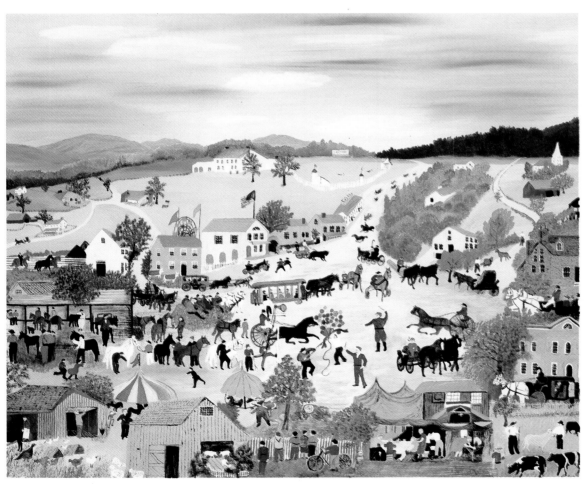

Country Fair

1950; oil on canvas;
35 x 45 in. (109 x 114 cm).
Moses' several versions of this theme reflect the importance of the various local and county fairs which, climaxing the growing season, provided farmers a chance to both display their products and livestock and to relax with friends and family.

They are less leitmotifs in the classical sense than a reflection of technique. The artist kept a clipping file of print illustrations which she used in figure design; the more useful she found an image, the more often it recurs. Several such images were often combined in a composition constructed by drawing directly upon the artist's masonite board (she rarely worked from nature, being a true "memory painter," and found little need for preliminary sketches).

As her career progressed Moses tended to focus more and more on the landscape backgrounds and less on these figures. The latter became abbreviations for activities, while the fields and hills developed from patterns into textural structures composed of rich, atmospheric hues. The line faded, and paint took over.

Though her technique evolved over the years, in part through her own development of new skills and in part through adoption of advice from friendly critics, Grandma Moses always remained true to herself (unlike those contemporary nonacademic artists who eagerly suck up any suggestions from dealers or agents in the hope that they might increase sales). She always preferred a smaller format, liked to add glitter to snow scenes (though some art critics thought this tacky), and simply would not paint certain subjects, such as religious scenes. Until her very last picture the artist's composition and color remained uniquely her own.

The Quilting Bee

1950; oil on pressed wood;
20 x 24 in. (51 x 61 cm).
Few social events were more important to country women than the quilting bee. It presented an opportunity to visit, to exchange gossip, to eat a communal meal and, most important, to create together something of beauty.

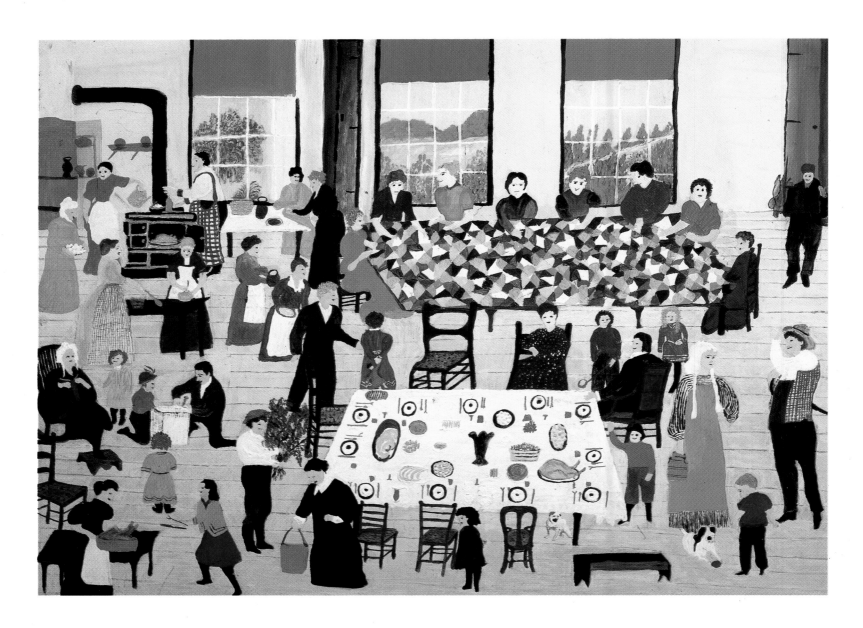

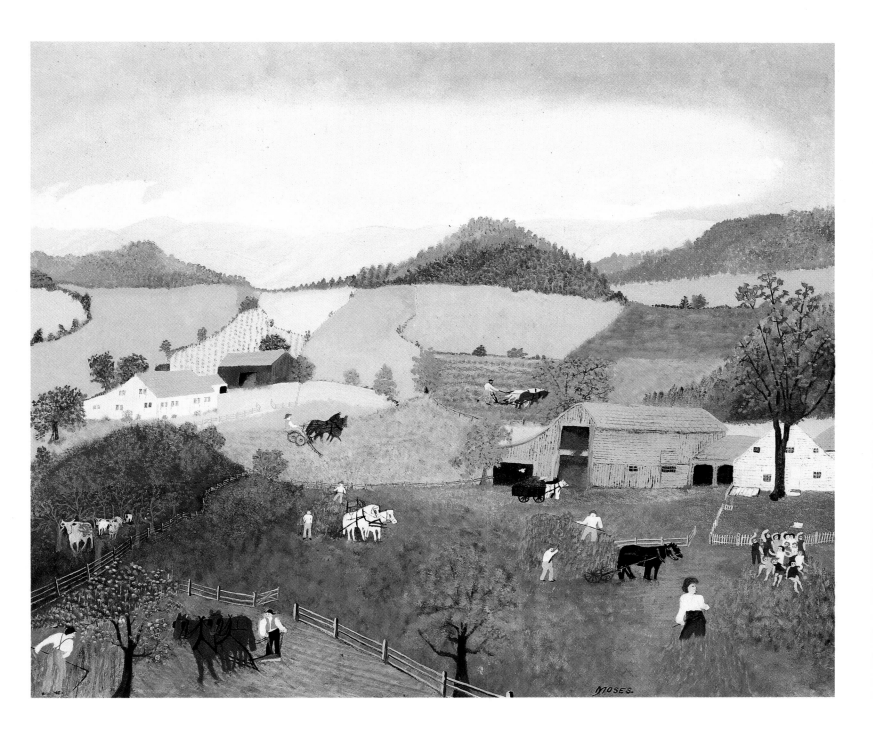

The McDonnell Farm

1943; oil on pressed wood; 24 x 30 in. (61 x 76 cm).
The Phillips Collection, Washington, D.C. While she did many generic
Hoosick Valley scenes, Moses rarely named a specific family farm.
One wonders if she might have once "hired out" to the McDonnells.

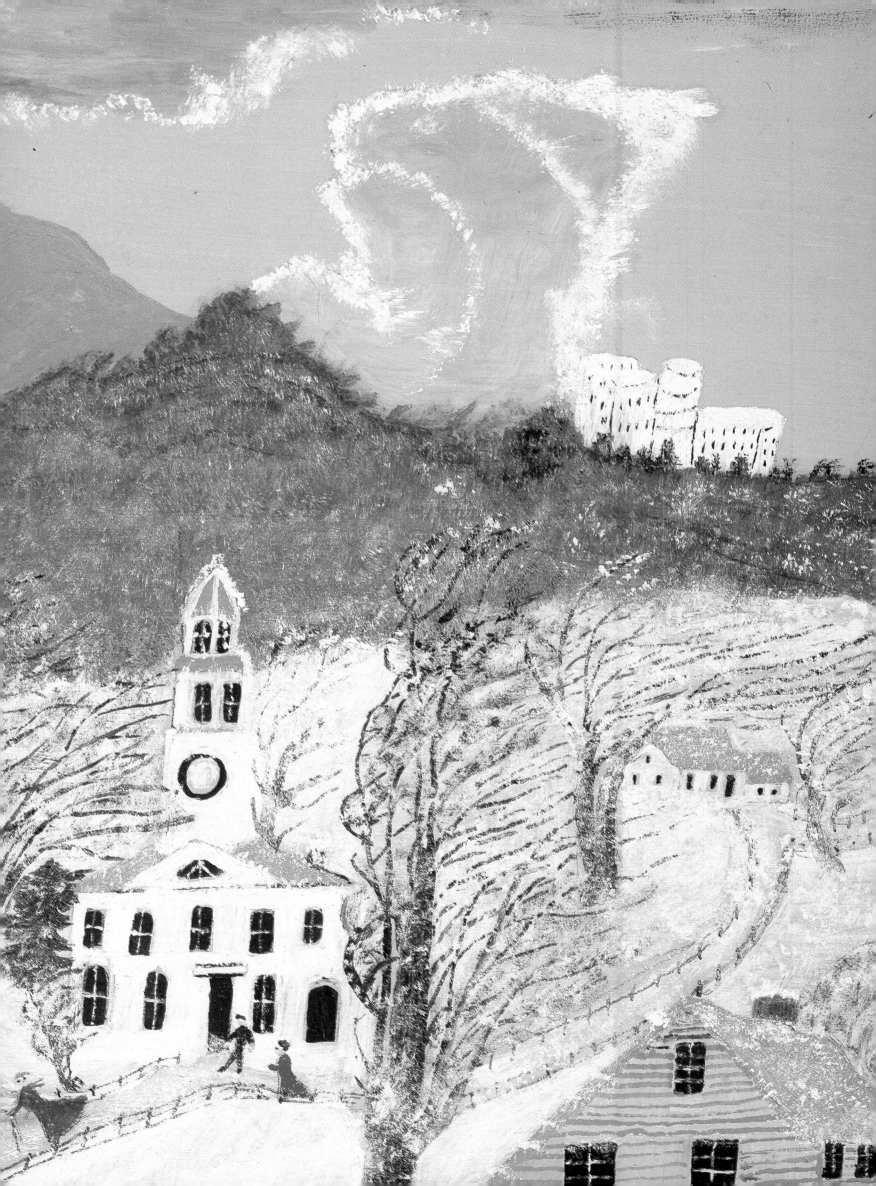

HOME TURF

The Landscapes

Though she could certainly create evocative interiors, Grandma Moses was primarily a landscape painter. As she once wrote to Otto Kallir's associate, Hildegard Bachert: "I tried that interior . . . but did not like it, so I erased it, that don't seem to be in my line, I like to paint something that leads me on and on into the unknown, something that I want to see away on beyond."

Certainly a clearly expressed philosophy yet, for Moses, the "away on beyond" was always an artistic abstract. She was not another Thomas Cole, dreaming of the Andes. In fact, she, like most people in her circumstances, traveled very little; when she attempted to set the scene of a painting in another state, as in *Missouri* (1943) or *The Eisenhower Farm* (1956), its locale still looked like the old homestead.

What she knew best and loved most was the narrow valley of the Hoosick River with the Green Mountains of Vermont floating on the eastern horizon, forming a frame within which the daily life of farm, dairy, and town went on, unchanged, in her paintings just as it had for two hundred years. The Hoosick pictures thus became a leitmotif in her work, a subject to which she returned time after time.

Her intimate connection to her immediate environment appears most obviously in *Hoosick Valley from the Window* (1946), in which she frames the lush verdure in a white lace curtain, in effect drawing the landscape into her home, and in *Hoosick Valley* (1942), where her surroundings become a great green carpet stretching away to the pale mountains of Vermont. But the valley had other seasons, and she captured them as well. In *Hoosick River, Summer* (1952) she depicts nature bursting with

the earth's natural riches, a sharp contrast to the scene in *Hoosick River, Winter* (1952), in which snow blankets the frozen earth and the bare trees form a background for a hunting party.

Cambridge, about six miles north of Eagle Bridge in Washington County, also had significance for the artist. The river valley terrain was similar, and it was here that her great-grandfather, Hezekiah King, had settled in the

Village Of Hoosick Falls
1943; oil on pressed wood; 18 x 23 3/4 in. (46 x 61 cm).
This summer view of the village emphasizes its business and industrial aspect with a rare view of the brick factories and a westbound train crossing the trestle.

A Blizzard *detail; 1956.*
Often overlooked in discussions of Moses' technique is her wonderful sense of movement. Here, Chagall-like figures move and flow with the same wind that churns the tree-tops and towering cloud banks.

Following page:
Bennington
1945; oil on pressed wood; 17 3/4 x 25 3/4 in. (46 x 66 cm).
Moses had family connections in Bennington, Vermont, and she herself lived there for two years. In this picture she illustrates the charm of the quaint New England village.

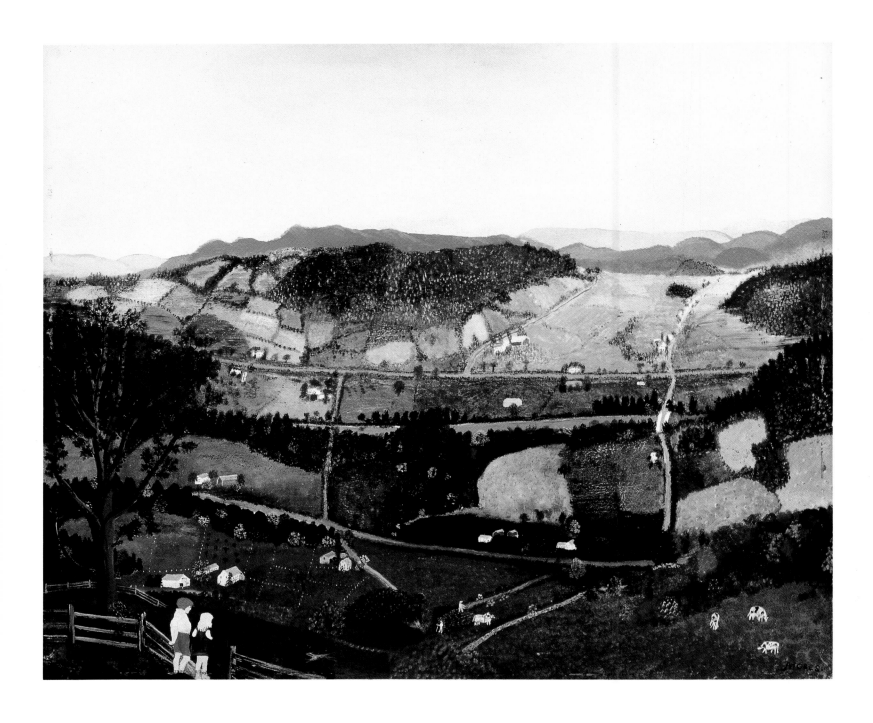

Cambridge Valley

1942; oil on pressed wood;
21 x 25 in. (53 x 64 cm).
Cambridge Valley represents one of
the finest achievements of Moses'
"patterning" method with the
beautiful valley laid out on the
canvas like a quilt or well-hooked rug.

late eighteenth century. In *Cambridge Valley* (1942) the artist captures the checkerboard-like patchwork of cultivated fields, pastures, and wood lots that made up a typical farming community. As with the Hoosick, Moses painted the Cambridge Valley in various moods and seasons. One example is the summer view entitled *Black Horses* (1942), in which the rolling hills form a background for two of Hezekiah King's horses.

Local market towns like Hoosick Falls and Greenwich also figured prominently in Moses' artistic documentation of her surroundings. Here there were stores and outlets for farm and dairy products, as well as mills and factories to provide off-season employment. The train which connected country to city passed through (though in her lifetime the artist saw the importance of the railway dwindle in favor of the horseless carriage); in *Hoosick Falls in Winter* (1944) Moses pictures the excitement occasioned in the snowbound village by the arrival of a steam engine and a few passenger cars.

On The Road To Greenwich (c.1940), on the other hand, pictures not the community but the way into it: a curving dirt road of the sort that, despite its limitations (deep mud in

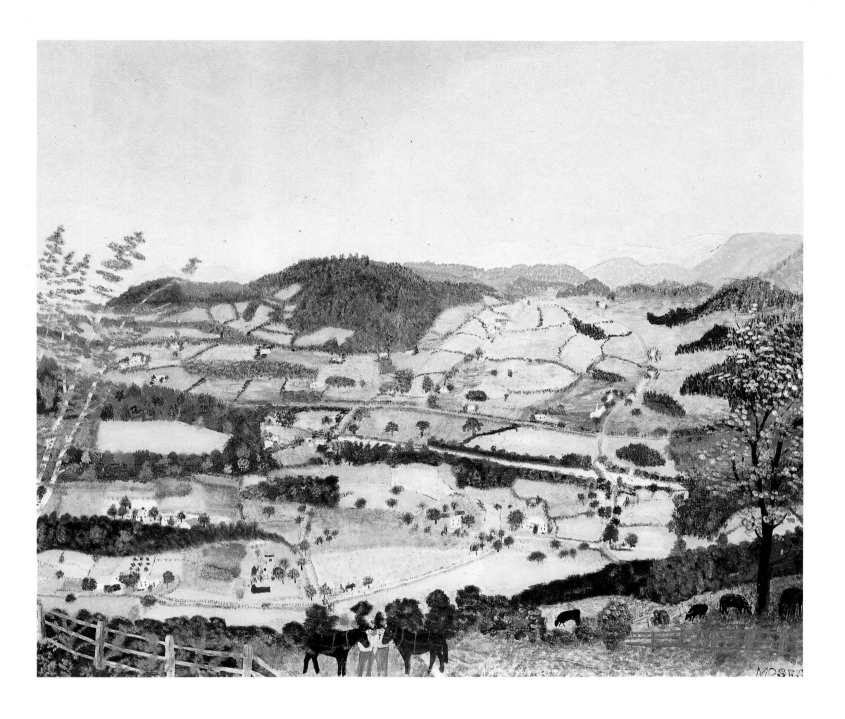

spring, dust in summer, and unplowed drifts in winter), was often designated a "turnpike," reflecting the importance of these narrow capillaries which fed the lifeblood of the country into the bustling market towns.

Few localities outside of her immediate area seemed to be of much interest to Moses. Troy, the nearest large city, is memorialized in eight versions of a disaster—*The Burning Of Troy, N. Y.* In one of these, *Great Fire* (1959), and the city is barely visible—just a burning bridge, embers from which will ignite it. Bennington, an important Vermont community east of Eagle Bridge, is pictured only twice despite the facts that Moses' daughter, Anna, lived there and the artist had spent several years in town with her. Little did she then realize that the state of Vermont would, in time, adopt her and her work (some New Yorkers regard the word "hijack" as more appropriate) as their own.

There is also a view—*Williamstown* (1947)—of a sleepy college town at the northwestern corner of Massachusetts some fifteen miles south of Bennington. One must wonder why Moses chose to depict a community to which she had no apparent

Cambridge Valley
1942; oil on pressed wood;
23 1/2 x 27 in. (60 x 69 cm).
The Cambridge Valley lying below the western slope of the Green Mountains was and is a beautiful area. Grandma Moses loved the district and painted it often.

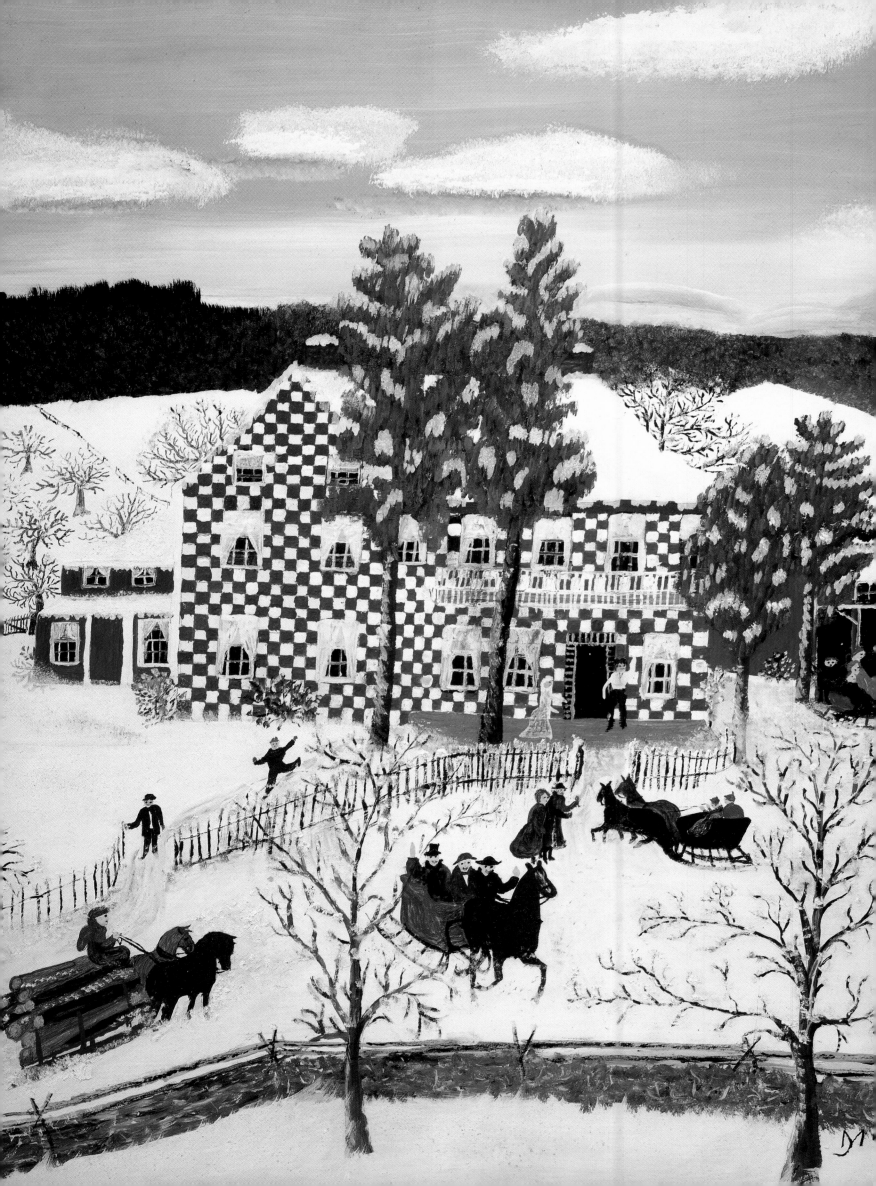

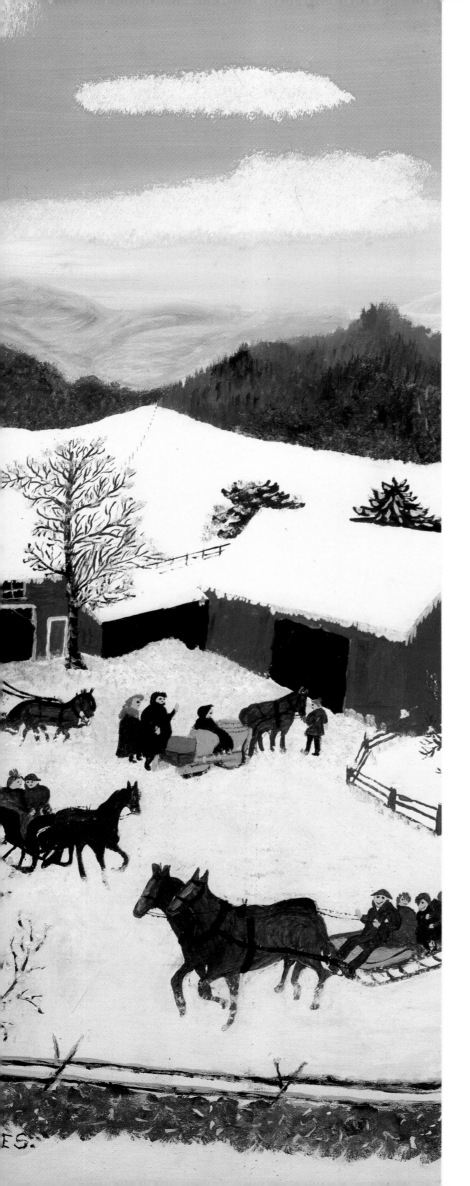

connection; it is suspected that this may have been a commissioned painting, perhaps for a resident or a Williams College alumnus.

Though she lived in the state of Virginia for nearly twenty years Grandma Moses had relatively little to say (on canvas) of that portion of her life. She loved the Shenandoah Valley very much, but only about twenty-five or so paintings depict scenes from that region. The overwhelming majority of her pictures deal with subjects from upstate New York and Vermont.

Moses also painted buildings or scenes that were important in her personal life or in the life of her community. The most obvious example of this is the Mt. Nebo series (see Chapter 5). Less common are representations of other local homesteads, a rare example of which is *McDonnell Farm* (1943), somewhat unique for the variety of activities taking place: a man plowing, another harrowing, another scything, others bringing hay from the fields, yet others unloading forage before a barn, and in the lower right-hand corner a group of children engaging in what seems to be an enthusiastic dance.

There is also a series depicting an eighteenth-century inn which once stood in the town of Cambridge. Known locally as "the old checkered house" for its venerable age and the fact that it was painted in a light and dark checkerboard pattern, this large building served as an inn and stagecoach stop, Revolutionary War headquarters and hospital and, of course, a private home. Though it burned in 1907, Moses remembered it from her youth and depicted it in all its former glory.

In *Checkered House* (1955) the inn is seen as it might have appeared in Revolutionary times, with soldiers in uniform standing about in the snow in front of the building. In *The Old Checkered House* (1950), however, it is still winter but here it's a happier time. The soldiers have vanished to be replaced by exuberant children and a proliferation of sleigh-borne merrymakers. Many of the same people appear to have returned in horse-drawn carriages for *Checkered House* (1943) and *The Checkered House In Summer* (1944). All these paintings center on the large, old colonial structure fronted by four tall pine trees and its surrounding outbuildings, yet every one presents a slightly different perspective: some close,

The Old Checkered House In Winter
1950; oil on pressed wood; 19 3/4 x 24 in. (50 x 61 cm).
One of Moses' favorite subjects, the Old
Checkered House was a familiar inn and
a gathering place for the community.

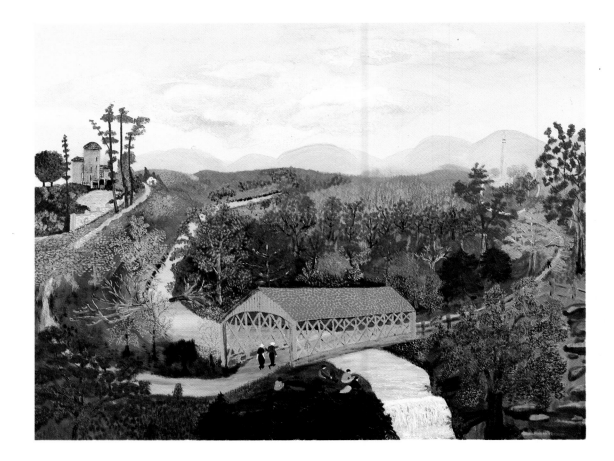

In the Park
1944; oil on canvas;
36 x 45 in. (91 x 114 cm).
This is a dream-like and
impressionistic pastoral
scene with figures crossing
a covered bridge on a
path which leads to
the distant Bennington
Battle Monument.

some farther away, each from a slightly different angle. Grandma Moses never repeated herself.

Another favorite subject was the hotel which once stood in Moses' home town. First constructed around 1800, it had burned and been rebuilt twice when, in 1916, it went up in flames for the last time. By then the railroad which had provided most of its customers was rapidly being replaced by the automobile. In *The Eagle Bridge Hotel* (1959) Moses pictures the old hostelry in happier times, when transients crowded its dining- and bedrooms and the locals came by for a drink or to catch up on the latest news.

Though certainly an intelligent and rather well-informed individual, Grandma Moses, like many people of her generation (particularly women), was denied the benefits of a full formal education. As she says in her autobiography: "Schooling was in those days in the country three months in summer, three in winter; little girls did not go to school much in the winter, owing to the cold, and not warm enough clothing, therefore my school days were limited, but I was kept busy helping at home and the neighbors."

Thus Moses' *The School House* (1949) can be viewed with a certain poignancy as the distillation of memories of those few brief months when, as household help, she was allowed to accompany her employer's children to the local one-room schoolhouse.

Another subject that seemed to fascinate the artist was the covered bridge. Many were (and some are still) to be found in Rensselaer and Washington counties, and Moses depicted them both in needlework (*The Old Hoosick Bridge* [c. 1939]) and in oils such as *In The Park* (1944), in which a very typical American bridge is backed by a strange, domed building of the sort found in Victorian prints.

One of the most difficult things for most of us to grasp in terms of Moses' career is how long she lived and how many changes she observed. When she was a child the train and the steamboat were the predominant modes of transportation (though the horse and buggy, which appear frequently in her work, remained important into this century), yet she witnessed their gradual replacement by the automobile and the airplane. As a landscape painter she usually subordinated these developments to her overall composition, but they do appear and, in some cases, can be the focal point of the work.

While still living in Virginia she saw the advent of the auto, which she memorialized in *The First Automobile* (c. 1939), the subject of which she described as being "as high up as it was long," though this was certainly not true of the open touring car which dominates the composition. On the other hand, a 1944 rendition of the event, *The Old Automobile*, subordinates the vehicle in a

typical Moses landscape and depicts the classic conflict between horse and horseless carriage ("this road isn't big enough for both of us!").

Lighter-than-air vessels were obviously another great change. Moses' *The Balloon* (1957) memorializes what must have been an astounding event in her life and that of her neighbors. As she later described it to Otto Kallir, "It was the year of 1907. I remember seeing a balloon going over from Argyle to Cambridge, New York, there was a man, woman, and child in it. They landed in Cambridge."

The balloon and the airplane (she saw her first around 1911) produced great changes in American society, but like the auto and the train they remained subordinate in her work to what really mattered, the seasonal life of the farm. Thus, in *The Balloon* the aircraft is but a tiny speck vanishing beyond the farmyard, whose inhabitants have hardly noticed it.

The Old Automobile
1944; oil on pressed wood;
18 3/4 x 21 1/2 in. (48 x 52 cm).
In this amusing painting, Grandma recalls an early encounter with the automobile, the first models of which were often restricted by low speed-limits (5 miles per hour) designed to protect horses.

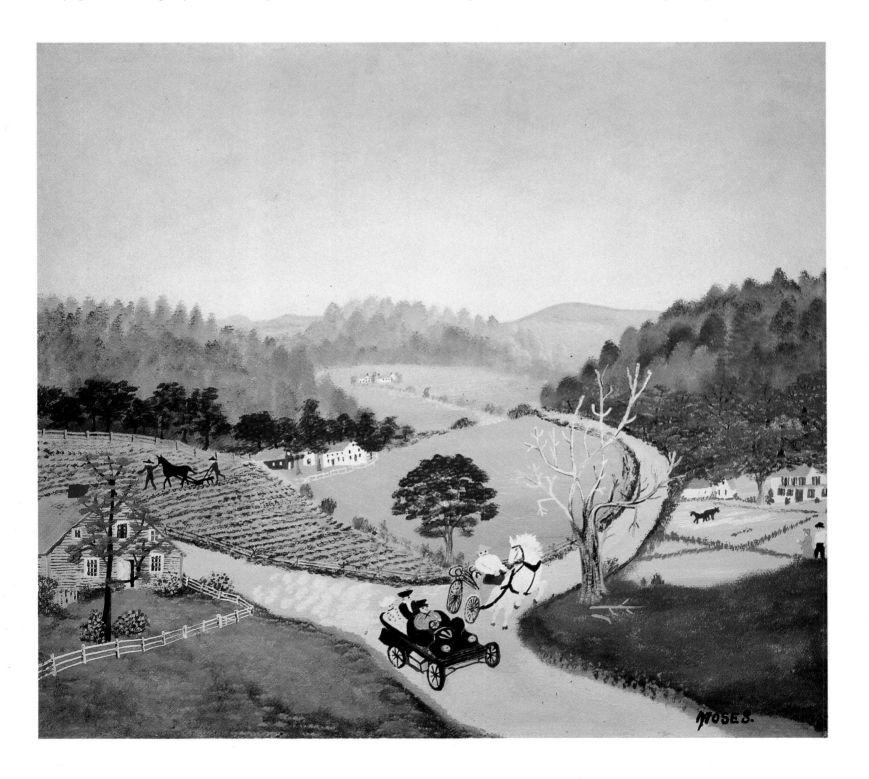

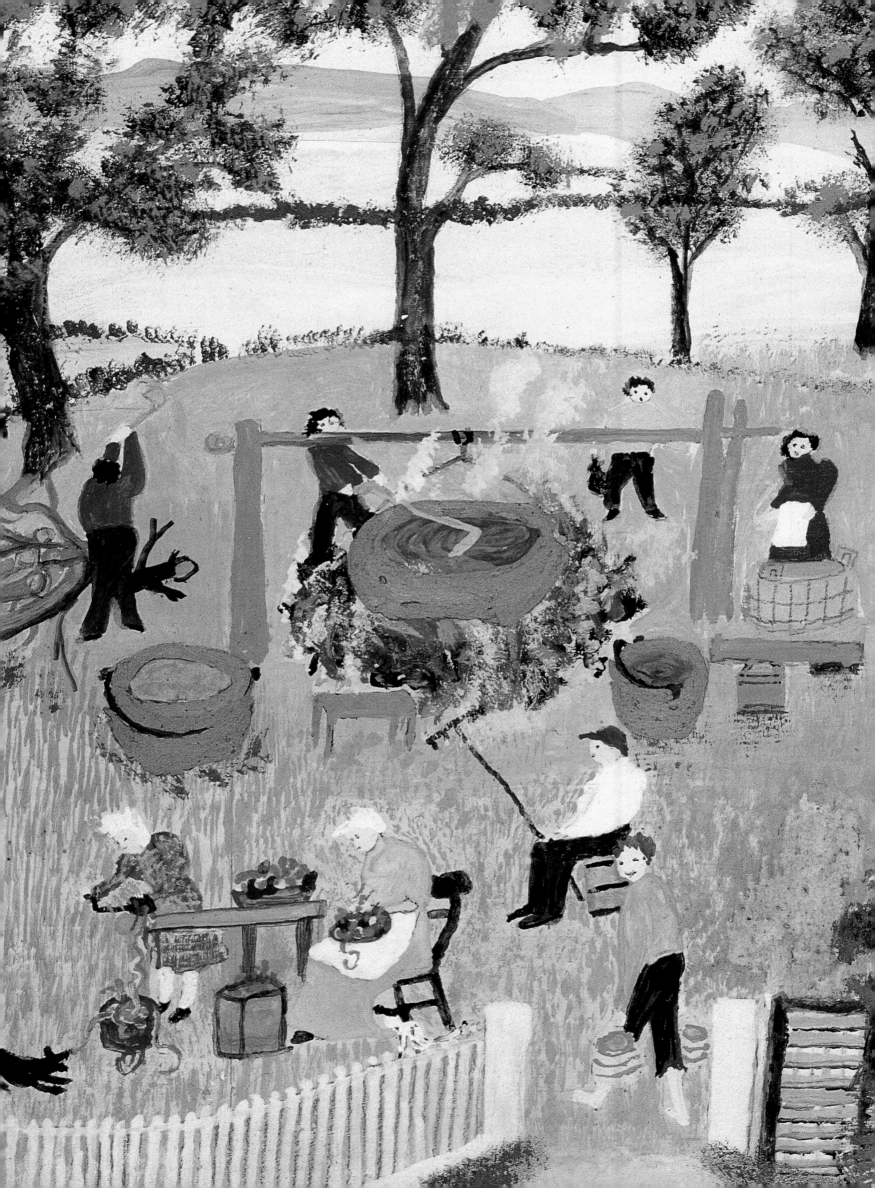

Images of Farm Life

In a century of rural life Grandma Moses saw and took part in every activity associated with traditional farming, and she documented much of this in her work. Many customary chores, such as haying, quilt making, and husking corn, were already well known to the American public through Currier & Ives lithographs and popular magazine illustrations. While Moses at times drew upon these for inspiration, her work was always informed by her lifetime of experience.

Thus her numerous versions of work in the maple bush, while clearly owing something to the 1872 Currier & Ives *Maple Sugaring—Early Spring In The Northern Woods*, include details that could be known only to one familiar with the complete process from maple sap to maple syrup and sugar. For example, the group of happy children in the center of *Sugaring Off In Maple Orchard* (1940) are partaking of "jack wax," maple syrup poured and hardened over snow.

Likewise, the detailed knowledge of every step in the process, from spiking the maple trees to carrying the sap pails with a shoulder yoke and employing ox-drawn sledges to transport wood for the evaporating fires, reflects an intimate knowledge acquired through years of first-hand observation.

This translation of life into art is no better realized than in Moses' *Applebutter Making* (1947), the process for which she described in *My Life's History* as follows:

> Late summer was the time for apple butter making. The apple butter was considered a necessity. . . . To make apple butter, you take two barrels of sweet cider (you grind apples and make sweet cider first), then you put them on in a big brass kettle over a fire out in the orchard and start it to boiling. You want three barrels of quartered apples, or snits, as they called them, with cores taken out, and then you commence to feed those in, and stirring and keeping that stirrer going. . . . Women folks would keep that going, feeding in all the apples till evening. Then the young folks would come in to start stirring. . . . They'd have a regular frolic all night out in the orchard.

All these activities are seen taking place in *Applebutter Making* in addition to a few Moses doesn't mention, such as the women in the foreground peeling apples with an old-fashioned patent cast-iron peeler and, of course, fruit picking in the orchard.

Farming was (and still is) hard work for minimal financial reward. However, many tasks were shared ones, making it possible to turn at least part of the drudgery

May: Making Soap, Washing Sheep
1945; oil on pressed wood; 17 1/2 24 1/4 in. (44 x 61 cm).
Only Grandma Moses could have succeeded in making two of the dirtiest, hardest, and most odorous of farm chores seem quaint and even pleasant!

Applebutter Making *detail.*
Despite their great variety of detail, Moses' paintings also had a core motif, something that unified the work. Here it is the great iron kettle in which the apples were cooked and stirred into a tasty paste.

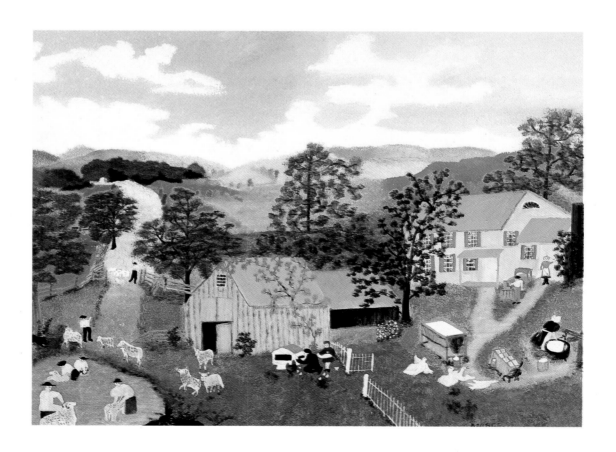

into play. This was certainly true of maple-sugar manufacture, and Grandma Moses also makes applebutter making sound pleasant enough, at least for the young.

Perhaps the most sociable task of all was husking corn. In *Husking Bee* (1951) Moses caught the convivial spirit of this event. While a group gathers about the mound of unshucked corn (the young men hoping, perhaps, to find the rare red ear which will entitle them to a kiss from a favorite girl) others dance to the tunes of fiddle and guitar or chat intimately. No one appears to be working too hard!

Grandma Moses also depicted necessary tasks that gave their participants little joy. In *May, Making Soap* (1945) she illustrated the process by which soft soap was made from lye (obtained by leaching the household ashes) and grease. It was a hot, smelly job. Nor can much be said for candlemaking, a traditional fall chore which Moses herself described as "tiresome." In *Candle Dip Day* (1950) she shows household candles being formed in the ancient manner, by dipping cotton wicks over and over into a vat of hot tallow. However, in her memoirs she indicates that tin molds were usually used, a faster and more efficient process. Either way, like soap making, it was not a task to draw a crowd.

While most communal activities took place outdoors, there was one important indoor activity: quilt making. As a traditional female pastime, quilting provided an opportunity for women to gather together not only to gossip and exchange recipes but also to provide support for each other in a society where life was hard and self-expression was often very limited.

The communal quilt, frequently made for a favored minister or a "sister" who was moving west, was both an offering and a bond among neighbors. This was particularly true of the friendship quilt, which consisted of many individually-made squares, each signed by its creator before it was sewn into the final product. In *The Quilting Bee* (1950) Moses captures the atmosphere of such an event. While a few men pass through the scene, it is the women, gathered about the quilt stretched on a great wooden frame, preparing dinner, or keeping track of their numerous children, who dominate the painting. This is their space and their time.

There were also some purely leisure activities on the farm, generally taking place during the late fall and winter when most of the agricultural chores were suspended. Barn dances, a social evening for young and old (but especially for courting couples), were held throughout the quiet season. In *The Barn Dance* (1950), Grandma Moses pictured a warm evening with squaredancers congregating in a great drive-through barn, where they frolic to the music of a small band as carriages laden with other revelers pull into the yard. Moses is always full of surprises. In this example, as in her other group scenes, it pays to examine what each individual or group is doing.

Winter sports were also an important part of rural life. In upstate New York frozen waters and snowdrifts are

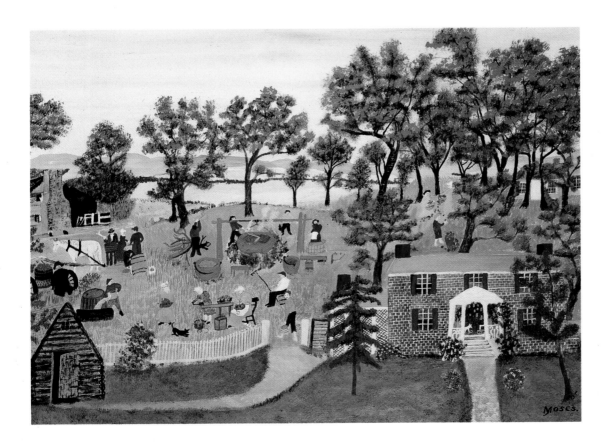

Applebutter Making
1947; oil on pressed wood;
29 1/4 23 1/4 in. (74 x 58 cm).
The manufacture of applebutter, one of the few sweets available over the long winter, was a traditional fall event combining hard work with merriment and sociability.

Snowballing
1946; oil on pressed wood;
27 x 21 in. (69 x 53 cm).
Long, snowy winters encouraged outdoor activities such as the snowball fight depicted here. Sledding and rides in horse-drawn sleighs were less aggressive but equally-satisfying winter sports.

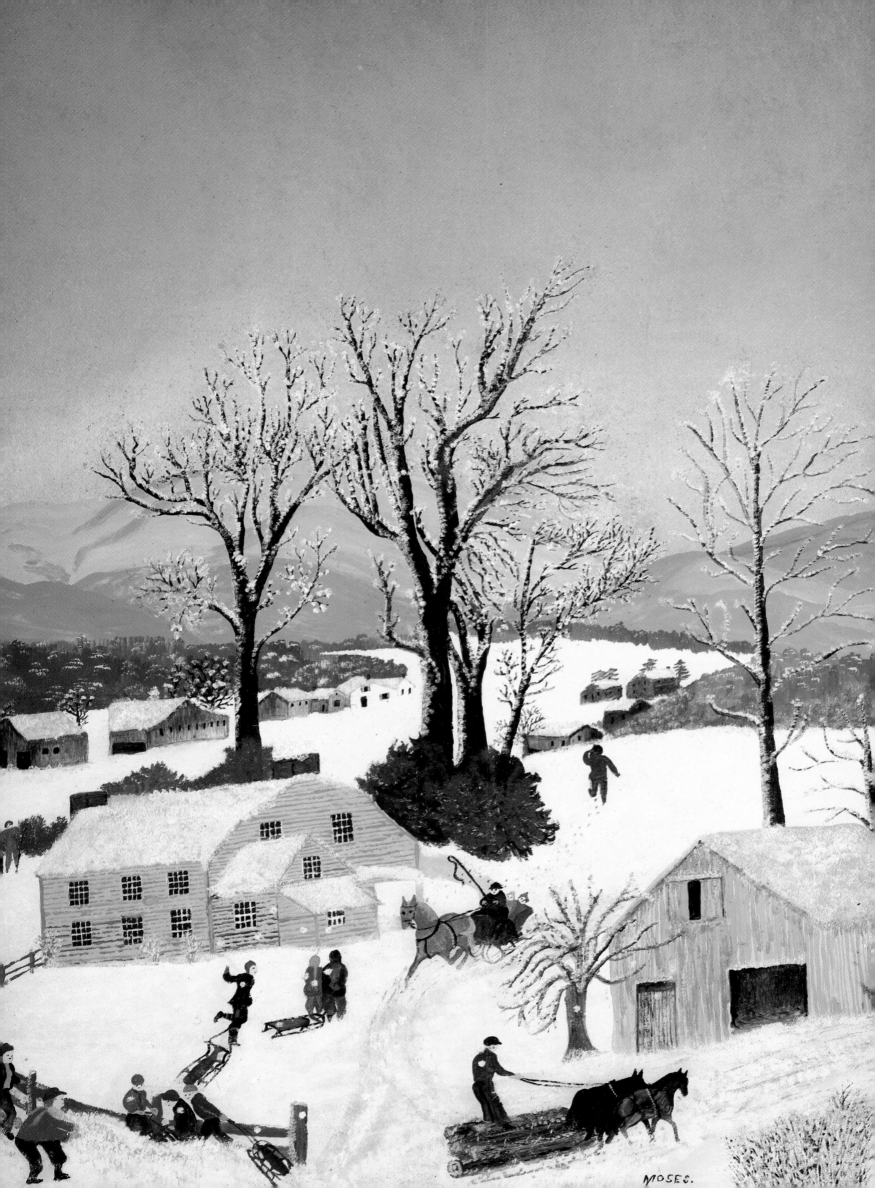

often the norm from November through March, allowing much opportunity for skiing, skating, and other cold-weather activities. Children of every age, then as now, were drawn to the possibilities inherent in soft, wet snow. "Good packing" meant snowmen, snow forts, and, of course, the snowballing which Moses captures so well in her painting of the same name.

While skiing, introduced from Scandinavia, was not a common rural sport, skating on the ice-bound ponds and streams was a popular diversion, particularly during the evening hours when bonfires were built along the shore and couples on skates with long, curling blades, clutching tiny glowing "skating lanterns," glided like fireflies across the frozen wastes.

Currier & Ives produced a well-known skating scene, *Central Park, Winter—The Skating Pond*, and in her own example, *The First Skating* (1945), Moses adapted certain elements of this lithograph to create a pastorale in which Manhattan's wealthy, fur-clad skaters are transformed into a group of spirited bumpkins.

While ice-skating has increased in popularity over the years, with indoor rinks extending the season by many

months, another popular winter activity has largely vanished. Until the early twentieth century most roads were made of dirt, gravel, or cobblestones. Mud and dust were the traveler's constant companions except in winter, when fresh snow, compressed by the ox-drawn sledges that passed for snow plows provided a hard, smooth surface for the horse and sleigh.

It is difficult for us to imagine the excitement that sledding brought to a largely static society. In New York City sleighs drawn by from one to four horses raced each other up and down Riverside Drive and along the Van Cortland Parkway, while in rural areas horses were hitched to anything with runners and turned loose on the ice-coated byways. In *Joy Ride* (1953) Moses pictured such a dramatic moment, as an open-work sleigh drawn by two draft horses careens around a corner amidst an admiring crowd of men, women, and children, some of the latter clutching their own downhill sleds.

Other activities were not so joyous. The artist was born into an uncertain period for agriculturists; by the time she was a teenager the rich Midwestern farmlands were drawing farmers from the stony fields of New

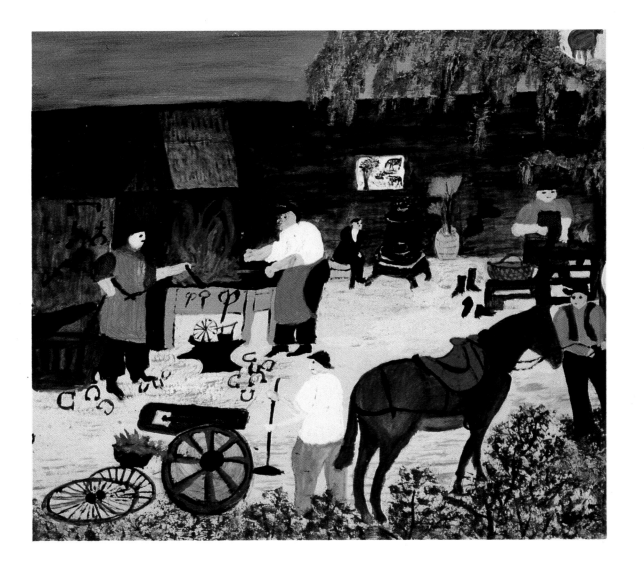

The Rainbow *detail; 1951.* While ostensibly focused on other things (in this case a rainbow), Moses' paintings were most often about the work of the countryside, here a busy blacksmith and farrier's shop.

A Blizzard
1956; oil on pressed wood;
15 7/8 x 24 in. (40.4 x 61 cm).
Winter could be menacing. A raging blizzard like this could trap unwary travelers, while heavy snowfall might leave the outlying farms cut off from town for days at a time.

England, while eastern mills and western mines continued to attract the young. She herself made a new life in Virginia, and then, nearly two decades later, followed the long road back to the Hoosick Valley.

In *Moving Day On The Farm* (1951) the artist illustrated the poignant moment when a farm family pulled up stakes. Like almost all of Grandma Moses' work, this painting has a very personal, intimate quality.

Seasonal Paintings

Grandma Moses was a farm girl and a farm wife. Whether in Eagle Bridge, where she spent most of her life, or on the farm at Staunton, Virginia, she took part in a pattern of activity that was to a great extent defined by traditional rural seasonal activities. It is not surprising then that many of her paintings mirror this yearly passage.

Winter scenes predominate, reflecting the fact that this season of stasis, when fields laid dormant beneath the snow and domestic animals were sheltered indoors, was a time both of preparation and of release. Farm families, freed from the daily round of planting, cultivating, and harvesting, could restore both their physical and emotional resources. Equipment was repaired, seeds bought or sorted, and, perhaps most important, decisions made without the daily pressure of tending crops and livestock in an unpredictable environment. Moreover, the year's most important holidays fell within this period, and her paintings of holiday activities are invariably snowbound.

Moses was clearly fascinated by the artistic possibilities of snow scenes. The sharp contrasts between dark human and animal figures and the gleaming snowy ground (often enhanced, despite her patrons' objections, by the application of flakes of glitter) intrigued her. But country winters were also a big part of her life. In contrast, Mattie Lou O'Kelley (b. 1908), perhaps the only other true rural twentieth-century memory painter (in the sense that they lived the scenes they depict), painted relatively few winter views. Perhaps this is not so surprising, however, since her home in Maysville, Georgia, was hardly in the snow belt!

Winter in the Hoosick Valley, hard on the slopes of the Green Mountains, was usually quite predictable: it snowed. The only variable was how much. Moses'

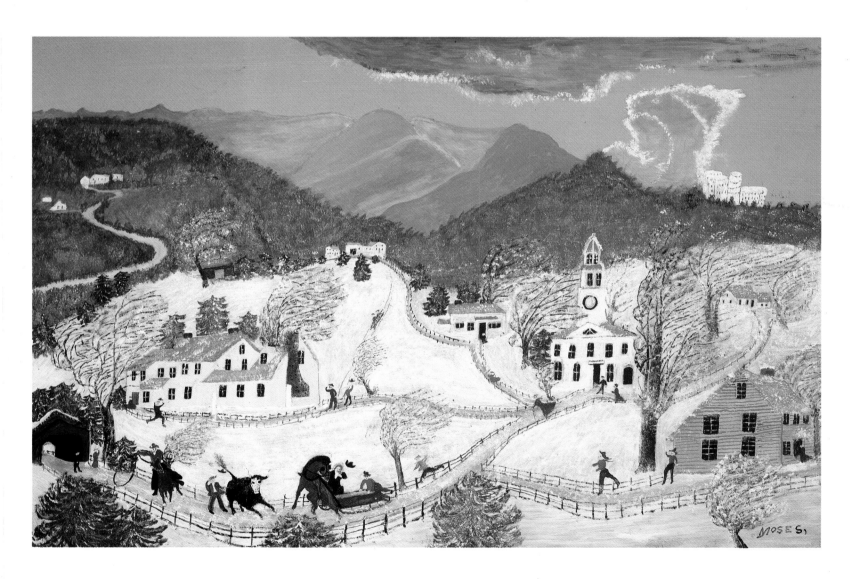

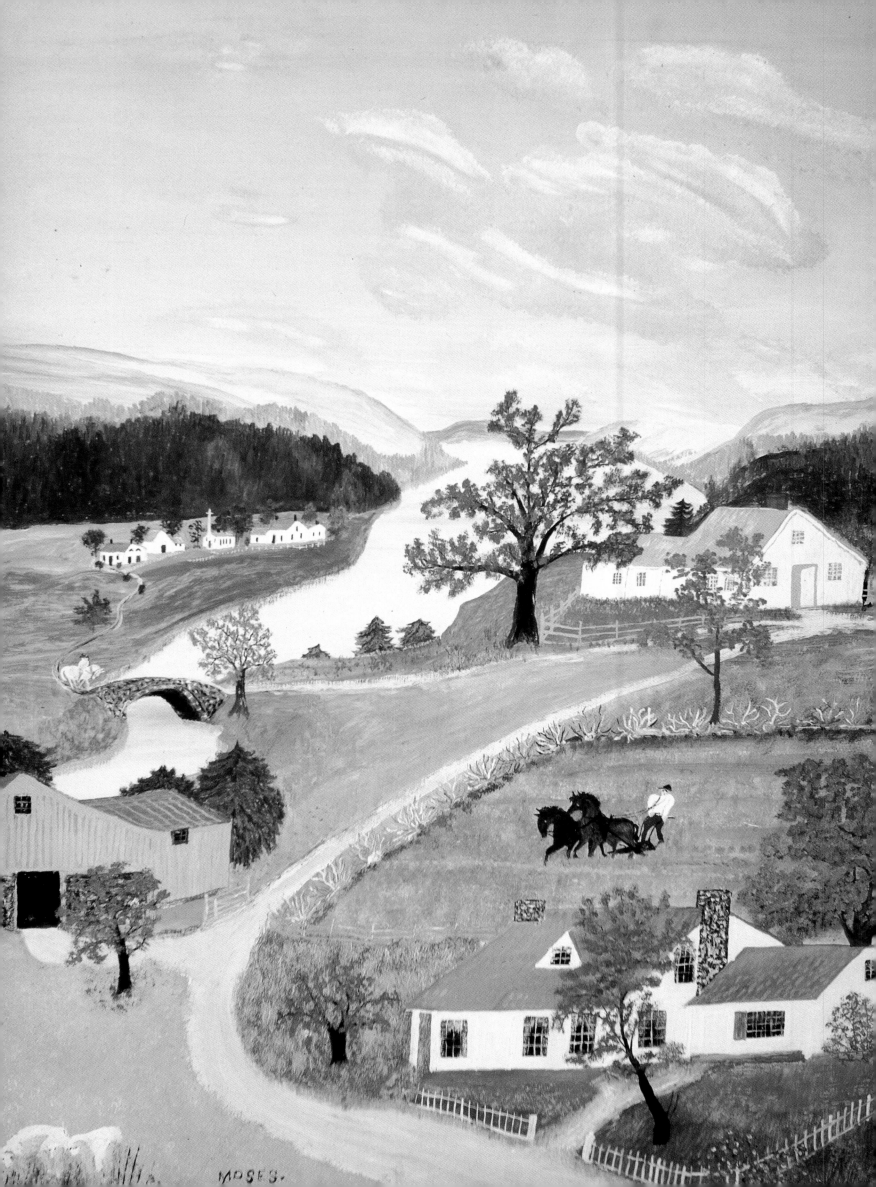

dramatic *Blizzard* (1956) captures this element quite well. The snow-laden wind roars through the valley, bending trees, blowing away hats, and disrupting horse-and sleigh-borne travelers. In the aftermath, as in *Hoosick Falls In Winter* (1944), the farms and villages lie shrouded in a thick white blanket awaiting the "breaking out," when ox-drawn sledges from isolated farmhouses gradually converged on the nearest village, packing down the snow along the roads so that they might bear the weight of sleighs, pedestrians, and horses.

Spring, or "mud time," as it is known affectionately in upstate New York, figures far less prominently in Moses' work. Winter extends its grasp far into the gentler season, and even such traditional vernal activities as gathering and processing maple syrup are set within a snowy context, for example in *Bringing In The Maple Sugar* (1939) or the late and unfinished *Sugaring Off* (1960).

However, pictures like *Early Springtime On The Farm* (1945) and *The Spring In Evening* (1947), the latter focusing on the traditional ritual of plowing the fields, remind us that, finally, spring will come. Moreover, other works like the lovely *Hoosick Valley From The Window* (1946) and *Down In The Valley* (1945), portray the season in all its glory, with flowering fruit trees set against the varying greens of farm and pasture.

Where winter brought blizzards, summer in the Hoosick River Valley could be sweltering, with periods of drought culminating in violent thunderstorms. Thus, Grandma Moses' summer scenes, such as the dreamy *Hoosick River, Summer* (1952) in which children play in a tree while the farmer follows his horses across the bountiful fields, stand in contrast to a few storm paintings in which turbulent (though brief) visitations of wind and rain sweep through the pastoral valley.

Often these storms seem to take the inhabitants quite by surprise, as in *Taking In Laundry* (1951), which depicts women continuing to wash and hang their clothes as moisture-laden winds bow the trees above their heads. The artist knew, though, that country people are far too sensitive to the elements for such behavior. A far more realistic response to an impending storm is seen in *The Thunderstorm* (1948), where the dark clouds and powerful gusts inspire an instant reaction: a load of hay is driven rapidly toward the barn to avoid the rain which would ruin it, and men scurry in from the exposed fields.

But this too will pass, and in the colorful and atmospheric *Rainbow* (1961) the storm has moved on, leaving a great multi-hued rainbow arching across the sky, while in the foreground the laborers return to their chores in the glowing fields.

Moses' fascination with both summer and winter storm scenes may be explained, of course, in terms of the opportunity for dramatic artistic effects which they presented. But this interest also reflected her agrarian life. Because a summer squall might destroy a season's crops or a blizzard strand and kill the unwary traveler, storms could never be far from the inhabitant's mind. Here, as elsewhere, the artist painted what she knew and what concerned her.

The fall season was and is a time of great activity on the farm. Crops are harvested, processed, and stored away

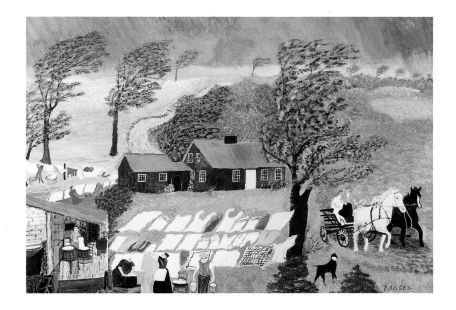

Taking in Laundry
1951; oil on pressed wood; 17 x 21 3/4 in. (43 x 56 cm).
Wind and rain were not much appreciated by the housewife.
When she had done the wash and hung the clothing up to dry,
a windy downpour might conspire to dirty and soak them all.

The Spring in Evening
1947; oil on pressed wood; 27 x 21 in. (69 x 53 cm).
In yet another seasonal painting, Grandma Moses
captures the soft, misty shades of early spring
as well as a traditional activity, spring plowing.

Following page:
In Harvest Time
1945; oil on pressed wood; 18 x 28 in. (46 x 71 cm).
As a farm wife, Grandma Moses was much in tune with the
seasons, and some of her most successful paintings evoke
the subtle changes in color which mark the passing of the year.

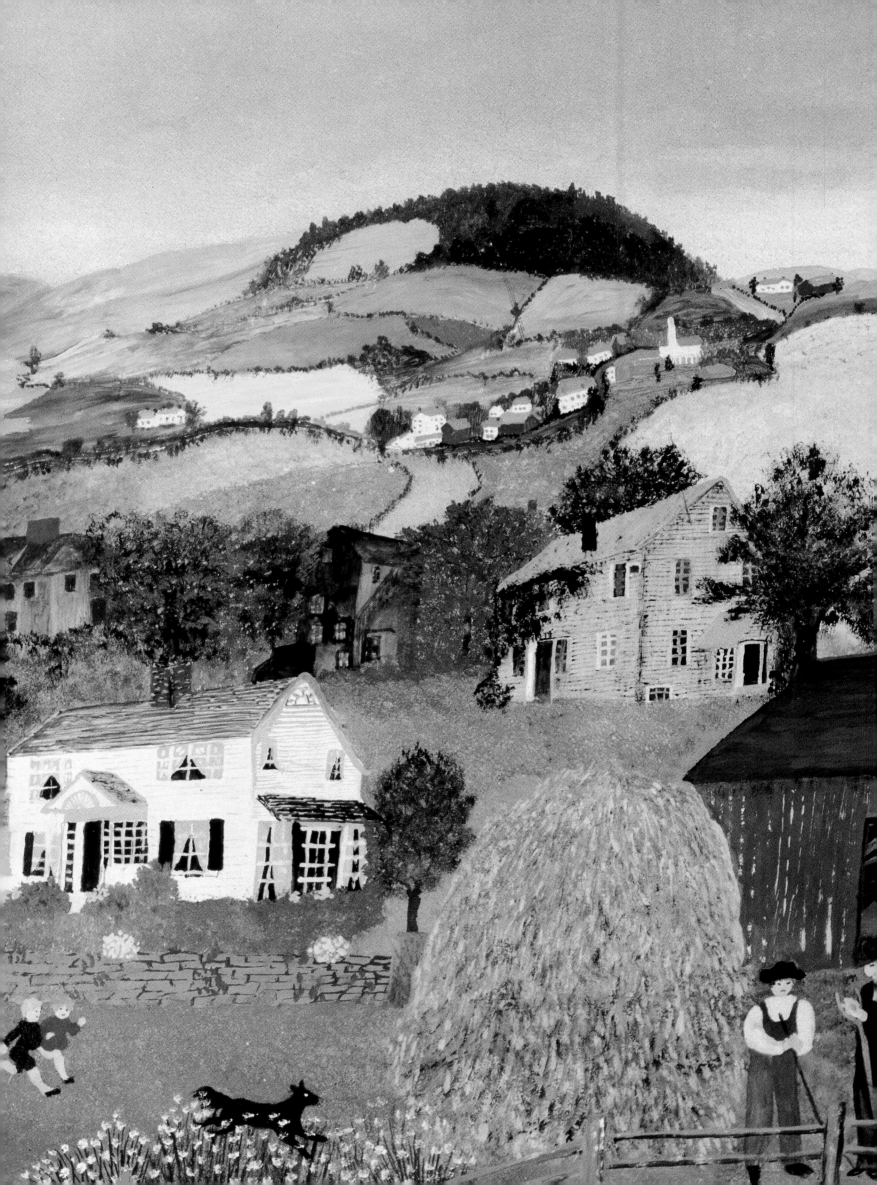

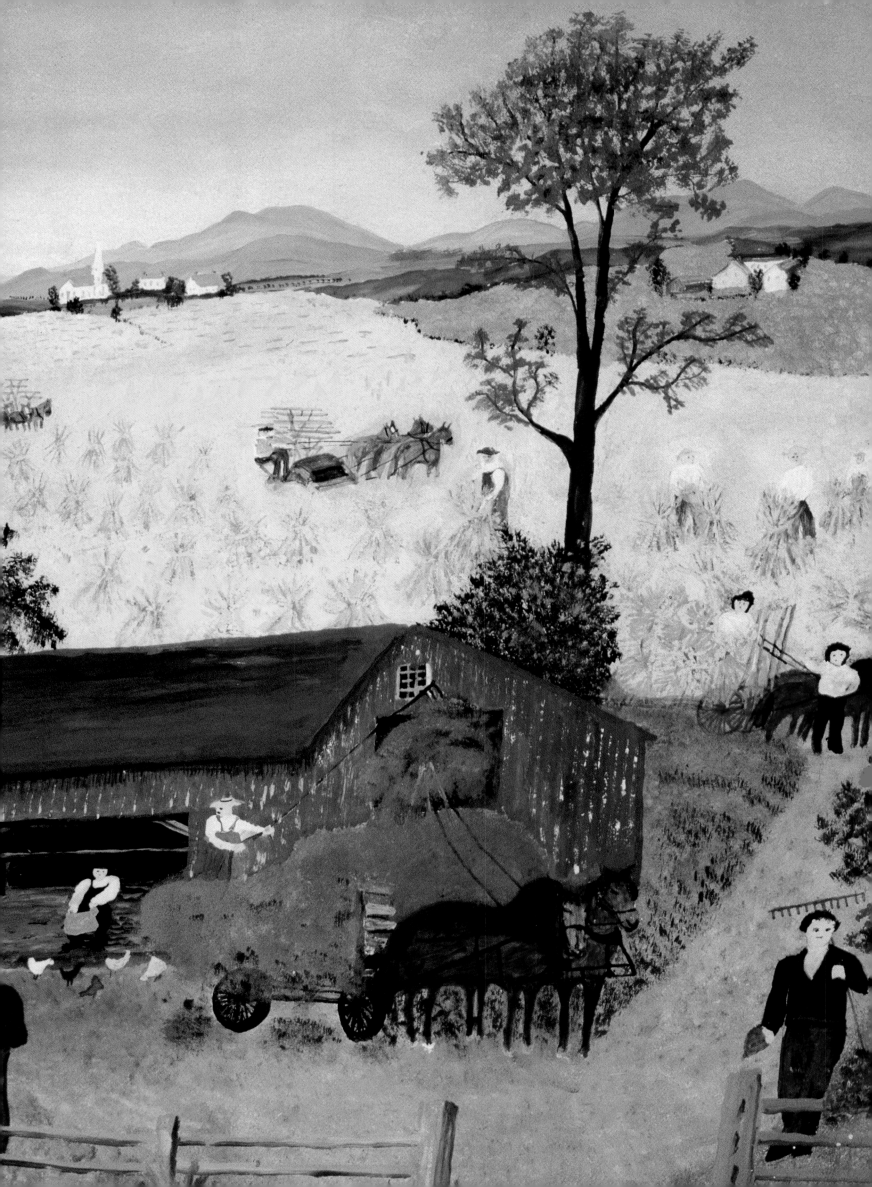

The Thunderstorm

1948; oil on pressed wood;
20 3/4 x 24 3/4 in. (53 x 64 cm).
Spectacular in force and appearance,
as seen here; thunderstorms were
much feared in the country. Rain,
wind, and hail might destroy crops,
while a bolt of lightning could bring
fiery destruction to house or barn.

against the coming cold. Animals are butchered for market or home consumption and the canning of fruit and vegetables reaches its peak. While Moses was quite willing to paint idyllic representations of the season—such as *Autumn Leaves* (1959), in which children frolic among the brightly hued trees, or *When The Leaves Have Fallen* (1950), where bare branches frame a group of farmers in rare repose—her main interest was in the season's chores. Thus, *In Harvest Time* (1945) captures a typical agricultural vignette, with the foreground dominated by workers forking hay from a loaded wagon into the barn loft, while in the distance another loaded wagon and a pair of silage cutters can be seen.

Pumpkins (1959) features a similar barn before which pumpkins have been unloaded from a cart. Here the focus of activity is the threshing floor upon which, in a scene worthy of Brueghel, figures with flails thresh grain. The seasonal cycle is complete.

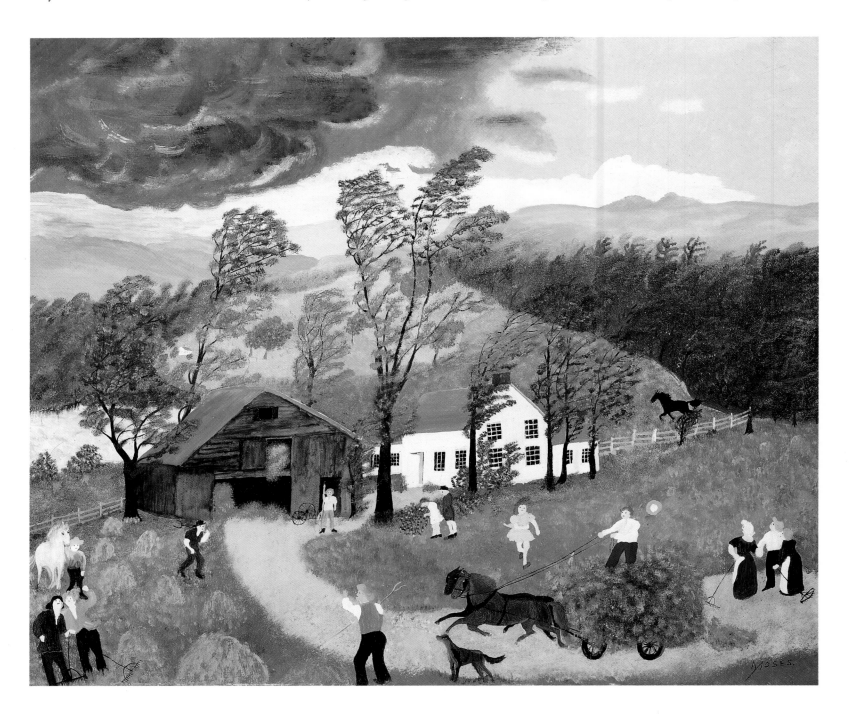

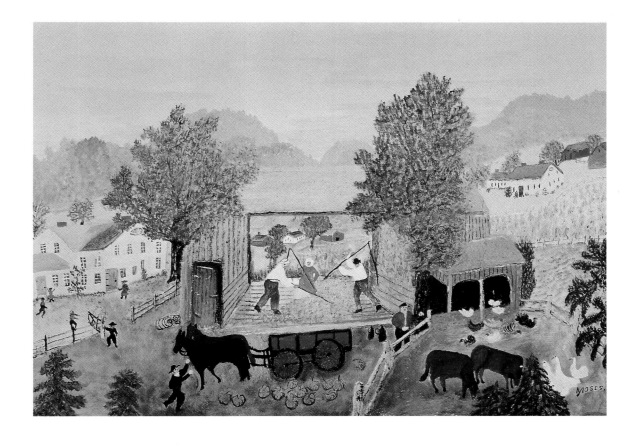

Pumpkins
1959; oil on pressed wood;
16 x 24 in. (41 x 61 cm).
Fall farm activities are
fully under way here with
workers threshing grain
in the walk-through barn,
while ripe pumpkins are
unloaded from a farm wagon.

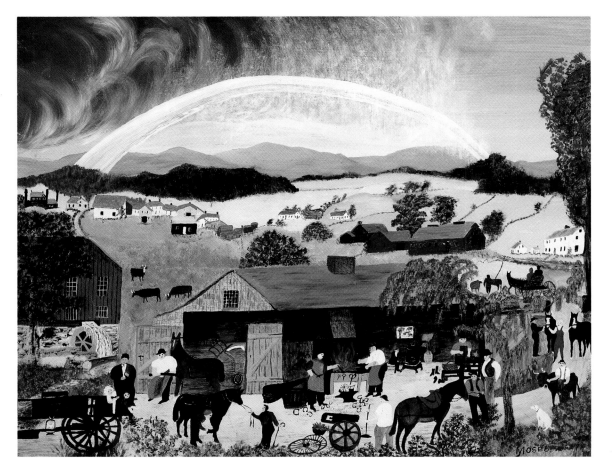

The Rainbow
1951; oil on pressed wood;
19 7/8 x 23 7/8 in. (51 x 61 cm).
A typical Moses combination
of a busy foreground focused
on a blacksmith's shop and
set against bucolic hills, over-
arched by a great rainbow.

CHAPTER FOUR

JOYFUL TIMES AND MEMORIES

Holiday Paintings

Grandma Moses produced a large number of works relating to traditional holidays, especially Thanksgiving and Christmas. The abundance of such paintings reflects both the importance of the holidays in rural communities, where they came as a welcome respite from months of drudgery on the farm, and the demands of the artist's clients who were particularly fond of such scenes. Indeed the latter consideration may well have led to the minor

proliferation in versions of the artist's popular rendition of the pre-Thanksgiving ritual pursuit of the elusive turkey.

Since she never duplicated a work, Moses' paintings of this subject vary substantially. In *Thanksgiving Turkey* (1943) the frantic chase is set in a barnyard which occupies the foreground of the painting, while in *Catching the Thanksgiving Turkey*, done in the same year, the vignette is compressed in favor of a dominating snowscape

Catching the Thanksgiving Turkey

1943; oil on pressed wood; 20 x 24 in. (51 x 61 cm). One of the artist's numerous variations on this traditional, pre-holiday theme, here set in a snowy valley with the participants framed by a lowering winter sky.

Night Before Christmas

detail; 1960. Like her landscapes, Grandma Moses' interior scenes were filled with details. In this Christmas Eve scene everything from the fireplace andirons and logs to the china on the mantel is in place, just as it would have been in her lifetime.

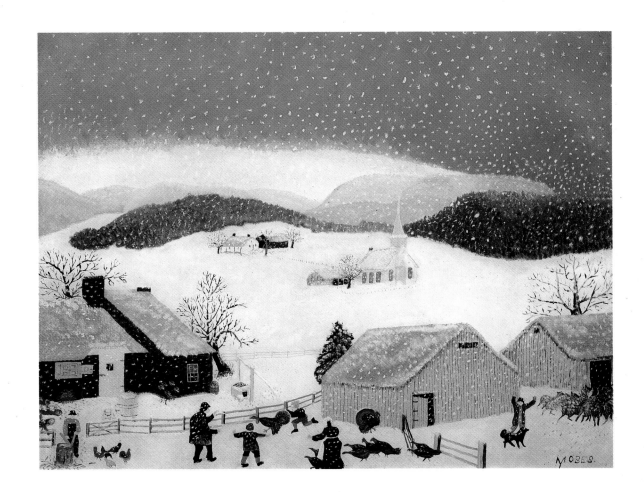

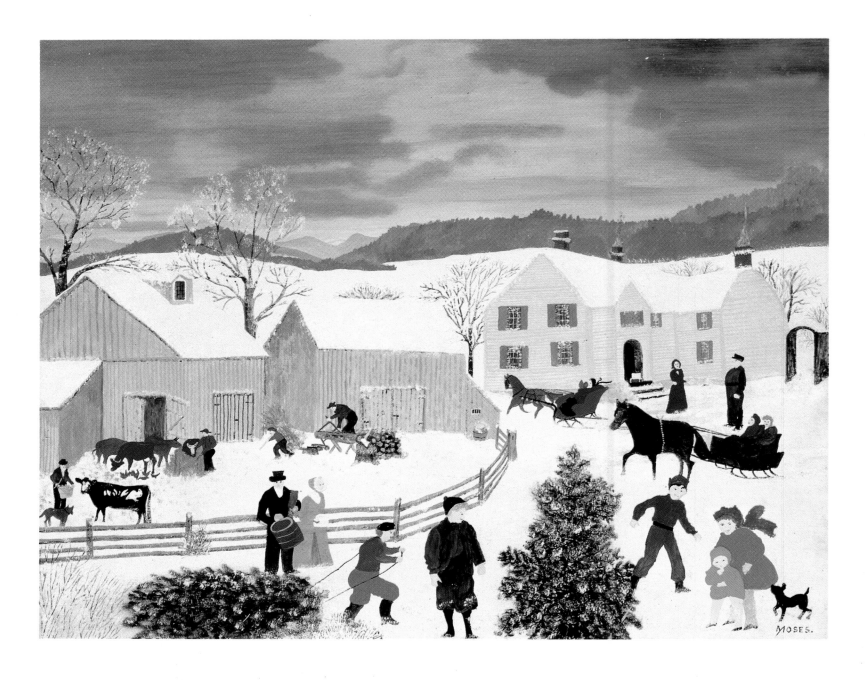

Here Comes Aunt Judith

1946; oil on pressed wood;
18 1/2 x 23 1/4 in. (47 x 58 cm).
In another view of pre-Christmas
rituals, children admire the newly-
cut trees, while a man saws the
yule log, and a holiday visitor,
Aunt Judith, arrives by sleigh.

featuring houses and a church. Another 1943 version of the same subject adds a sleigh and
hunter in the foreground while retaining a similar background of rolling hills. Yet anoth-
er variation (1940) gives equal space to the barnyard and an adjoining house while the dis-
tant hills have vanished from the scene.

All mine the same ground yet all are original. Some of Moses' earlier treatment of the
holiday, however, show much reliance upon the widely distributed Currier & Ives genre
lithographs, as in her *Home For Thanksgiving* (c.1939), in which the familiar scene of fam-
ily greetings at the door of the old homestead is taken from the popular *Home To
Thanksgiving*, done for Currier & Ives by the painter George H. Durrie.

The Christmas season paintings show a greater variety, covering every activity from the
search for an appropriate tree to the traditional family dinner. The wooded Hoosick hills
were thick with evergreens, and a few days before Christmas every family would select its
own for decoration. In *Out For Christmas Trees* (1946) Moses provides a panoramic view
of such community activity. Close inspection of the hilly, snowy vista reveals cut trees

being dragged home by hand or transported on sleighs and log skids, while eager woods-
men apply the axe to others.

The view in *Here Comes Aunt Judith (Bringing In The Christmas Tree)* (1946) is a more
intimate one, focusing on the family. The arriving sleigh-borne relative and the great
white farm house occupy our attention to the right while the tree is carried in from the
left; in the distance the yule log is being cut to fit the fireplace.

In *Night Before Christmas* (1960) and *Waiting For Santa Claus* of the same year the action
moves indoors. The former captures the silent, empty parlor with decorated tree, and
according to Victorian custom almost every surface, including chairbacks, windows, and
even picture frames, is draped in evergreen boughs. To complete the scene, two stockings
hang above the fireplace. In *Waiting for Santa Claus* the scene shifts to the children's
bedroom where, huddled four to the bed, they sleep "with dreams of sugar plums
dancing in their heads." Both of these belong to a series of illustrations that appeared in
a 1961 edition of Clement C. Moore's beloved poem *The Night Before Christmas*.

While Moses did several renditions of Santa's visit including *So Long Till Next Year*
(1960), a charmingly folky scene in which the old elf's airborne sleigh seems destined for

Night Before Christmas
1960; oil on pressed wood;
12 x 16 in. (30 x 41 cm).
If one is to judge by the number
of paintings devoted to it, Christmas
was one of Grandma Moses'
favorite holidays. In this version
she pictures the quiet time before
the arrival of jolly old Saint Nick.

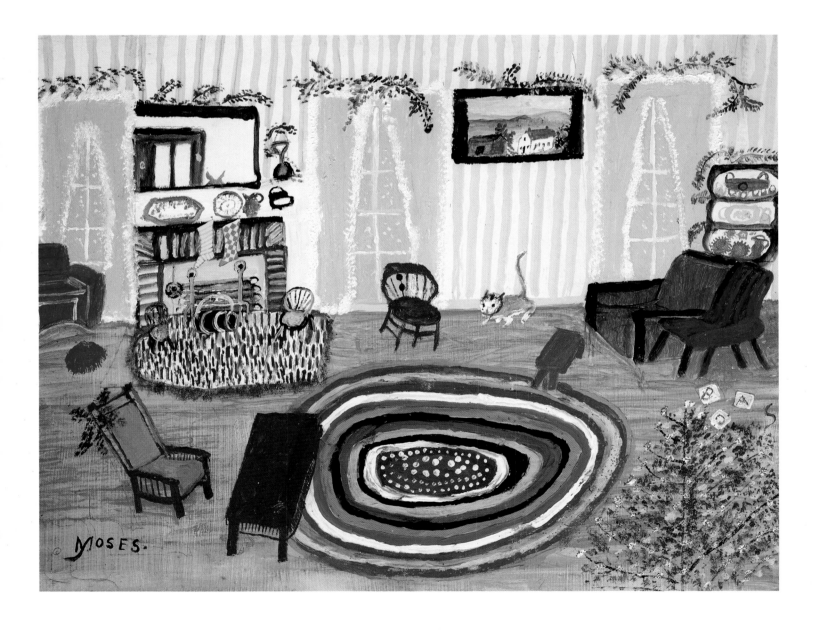

collision with a huge ice-festooned tree towering over the salt box house—she was more successful with *Christmas At Home* (1946). Though the artist did not like to do interiors—which often presented her with compositional problems—in this case, Moses created a work which has the quality of an appliqued sampler quilt, a textile form she would have been quite familiar with. The red flooring surface serves to bind together otherwise disparate vignettes, including tables set with food (which, themselves, become miniature quilts), a Christmas tree loaded with decorations and presents, playing children, gossiping elders, and even a two-person choir singing away in the corner.

The scene shifts abruptly in *A Tramp On Christmas Day* (1946), in which a family preparing to sit down to the traditional meal at a spread table glimpsed through an open door to the left is confronted with a reminder that all is not well with the world, even on this day. A wandering hobo has come to beg at the door. The housewife, carrying a great roasted turkey, turns to look, as does a young man munching sweets. What to do? Should he be invited in to join the repast (Christ would certainly have welcomed him), fed scraps in the kitchen, or turned away? The latter is unlikely. No doubt he found a meal and, perhaps, a bed for the night. Moses, like other memory painters, rarely chose to deal with social issues, though her own life was hardly an easy one; we can only speculate as to why she chose to portray a subject that many of her well-to-do patrons would most likely have preferred to ignore.

Among Grandma Moses' few other holiday paintings is a spirited rendition of the popular October holiday, *Halloween* (1955), featuring all the activities traditionally associated with the evening. In the foreground men unload barrels of cider while children bob for apples, all unaware that above their heads mischievous boys are performing yet another customary rite: mounting a stolen wagon on the roof! In the background girls costumed as ghosts flit about the barn, while on a far hill stands a pale abandoned house.

Halloween *detail; 1955.*
Moses often combined interiors with landscapes but seldom as successfully as here where activities in the home (seen as a doll's house view, an artistic device she often used for interiors), in the door yard, and on the roof are joined in a virtual symphony of color and movement.

A Tramp on Christmas Day

1945; oil on pressed wood; 16 x 19 7/8 in. (41 x 51 cm). The Shelburne Museum, Shelburne, Vermont. Wanderers were not uncommon in the country; nor, were they feared as they are today. It is likely that this one found a warm meal and a place to sleep.

Halloween

1955; oil on pressed wood; 18 x 24 in. (46 x 61 cm). Arguably one of the artist's most amusing paintings, *Halloween* depicts an old-time country celebration where harmless activities like bobbing for apples and cider drinking mingle with such traditional deviltry as placing a farmer's wagon wheels atop his roof!

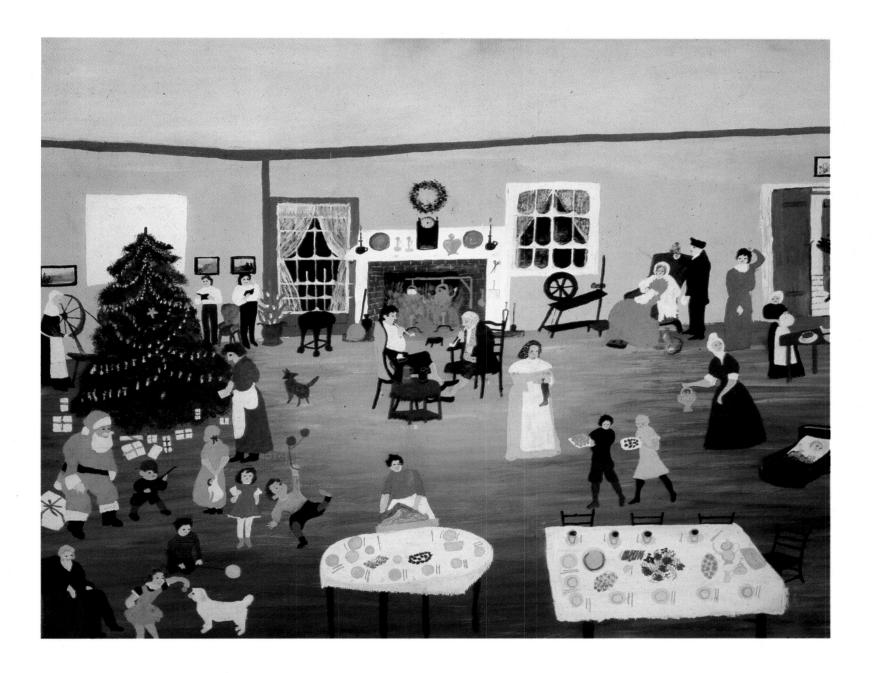

There were also the county and township fairs, great rural holidays where friends gathered for events ranging from trotting races and carnival-type games of chance to serious competitions for everything from the best pumpkin pie or hand-stitched quilt to the fattest pig or best-producing cow. Moses dealt with this subject at least twice, in *Bondsville Fair* (1945) and *Country Fair* (1950). Both paintings are set in small towns rather than on a traditional fairground.

Country Fair portrays colorful tents housing exhibits arranged among the community buildings, while amusement is provided by balloon dealers and even a tiny portable carousel. Prize pigs, sheep, and cows are stabled about the area, while the carriage sheds are filled with horses being exhibited or readied for the races. The scene at Bondsville is much less festive. A few dozen spectators admire a pen full of pigs, while nearby a cow is milked, a brace of oxen stand quietly, and a group of white-faced cattle enter the town square. The focus here is much more on livestock, much less on amusement.

Christmas at Home
1946; oil on pressed wood;
18 x 23 in. (46 x 58 cm).
In this view of the social rather than mythic side of Christmas, the holiday is seen as the reason for a great family gathering with several generations assembled in the ample living room.

Little Boy Blue

1947; oil on pressed wood;
20 1/2 x 23 in. (51 x 58 cm).
Moses' interest in traditional nursery
rhymes is reflected in a group of
her earlier paintings such as this one.
However, she transposes the settings
from their origional English sources
to her familiar Hoosick Valley.

Fantasy and Historical Paintings

Anna Mary Robertson Moses was above all a practical person. The vast majority of her paintings document her own life and times and those of her rural neighbors. Religious themes, a field popular to the point of cliché among many twentieth-century self-taught artists, held little interest for her, though she was certainly religious. Dream work and visions of the future do not appear. The past and present were quite sufficient for her.

However, in one area Moses did seem to deviate from historical reality: she painted several works based on nursery rhymes or old legends. Yet even in these she provided costumes and backgrounds that placed fictional characters squarely in her own late nineteenth- early-twentieth-century milieu. Thus, in *Little Boy Blue* the forgetful protagonist

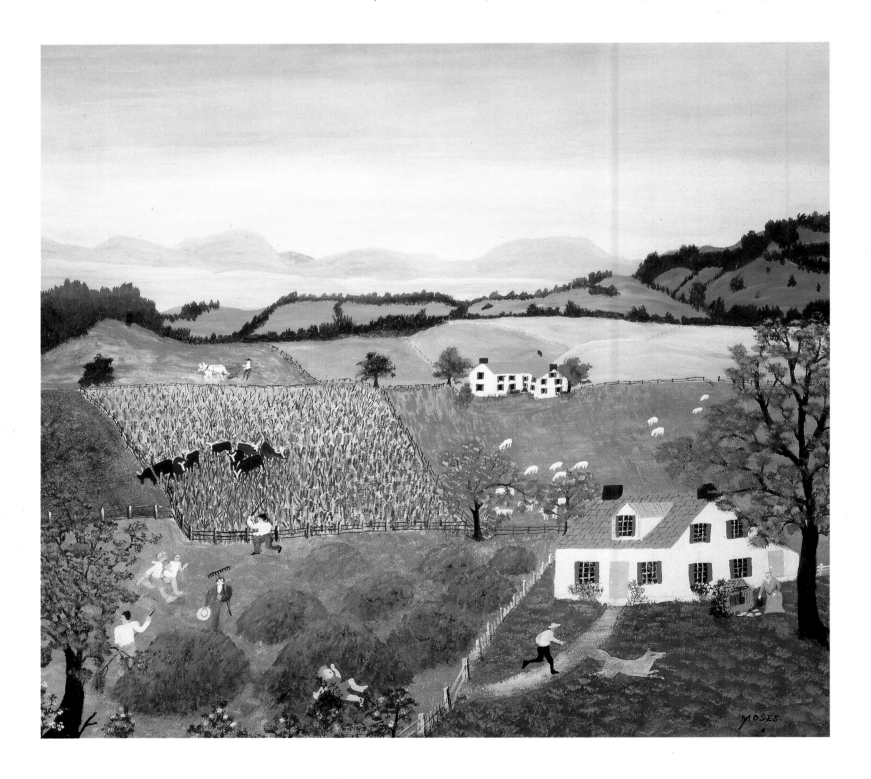

snoozes peacefully within feet of a center-hall colonial farmhouse (a prototypical American form), while the "cows in the corn" and the "sheep in the meadow" are set against the same rolling Washington County hills seen in countless other of her works.

Much the same may be said of *Tom Tom Piper's Son* and *Mary and Little Lamb*. In the former, a typical Moses winter scene, the thieving juvenile flees across a rail fence while the pig's owners count their loss among a group of porkers lodged in, of all things, a horse-drawn farm sleigh.

The scene in *Mary* is a schoolyard before a brick one-room schoolhouse similar to some which still stand in the Cambridge Valley. Mary, dressed like a nineteenth-century New England schoolgirl, is surrounded by classmates so typical of other Moses works that only the caption makes it possible for us to recognize the nursery rhyme inspiration. All three of these paintings date from 1947; Moses does not appear to have pursued the topics thereafter.

One legend, however—the story of the old oaken bucket—gave birth to several paintings. According to what Grandma Moses told Otto Kallir, she had, as a child, heard the tale of a local youth who, disappointed in love, went off to sea. Longing for home and family, he wrote some verses about the well from which he drank as a boy. Set to music, these became a popular Victorian aire, "The Old Oaken Bucket." Apparently fascinated by the theme, the artist explored it again and again.

Two examples, among numerous other versions, *The Old Oaken Bucket* (1946) and *The Old Oaken Bucket In Winter* (1950), appear to be summer and winter views of the same house and farmyard, with many of the same characters going about the same tasks in the same places regardless of season. Since Moses rarely repeated herself, this is clearly intentional.

Another area which the artist pursued to a limited extent was that of historical painting, a form of fiction in itself. Perhaps her best-known work in this category is *The Battle of Bennington* (1953), which was commissioned by the Daughters of the American Revolution. Compressing time as folk artists so often do, Moses painted not only the remarkably bloodless battle scene but also the monument which was erected some years later to commemorate it. When a spoilsport pointed out that the monument would not have been there at the time, she obliged her critic by doing a second version— minus the granite obelisk.

As a popular artist and artistic icon, Moses found herself called upon to complete commissions that seemingly had little to do with her own oeuvre. One such example is *Eisenhower Home* (1956), one of two views she did of President Eisenhower's Pennsylvania residence. Commissioned by the presidential cabinet, the piece illustrates Moses' ability to put her unique mark on any scene. Working only from photographs, she created a building which would have been quite at home in Washington County, New York.

Mary and Little Lamb

1947; oil on pressed wood; 24 x 34.5; (61 x 89 cm). In another of Grandma Moses' fantasy paintings, Mary and her pet are firmly grounded in the rich soil of the Hoosick Valley.

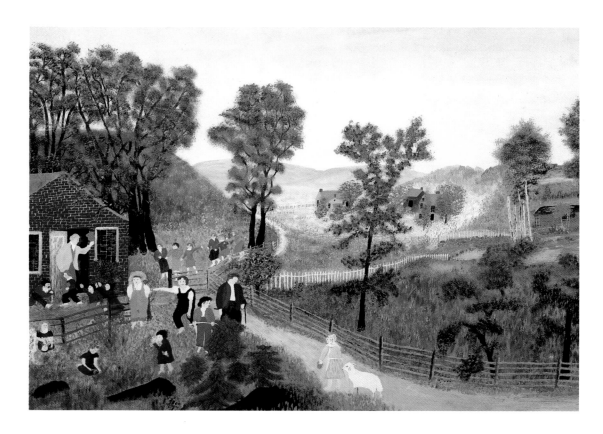

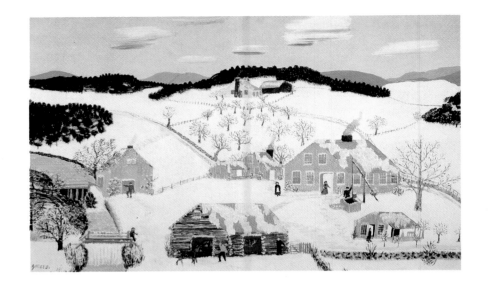

Old Oaken Bucket In Winter
1944; oil on pressed wood;
19 x 32 in. (48 x 81 cm).
This is one of several winter versions
of a theme which Moses returned
to time and again. It is based on a
local legend of lost love and an old
sweep-well's oaken water bucket.

Most of Grandma Moses' historical paintings were, however, based on subjects with which she was intimately acquainted. *First Wagon On Cambridge Pike* (1944) represents her version of a bit of family history. Her great-great-grandfather, Archibald Robertson (b. 1748), is said to have built the first wagon ever to travel the then newly opened Cambridge Pike; in this painting she recreates the momentous event.

The artist turned back the clock again in her familial depiction *Home of Hezekiah King in 1776*. King was a prominent early settler of the area, but one would never know this from the painting. The forests which covered the valley in the 1770s are gone, replaced by manicured fields and trim wood lots; the old well and familiar oaken bucket are in place, and a couple steps out in a

type of carriage which would not be invented for a half century!

In another work, *Great Fire* (1959), Moses pictured the nineteenth-century blaze that burned large parts of Troy, New York, a sizable city some twenty miles southwest of Eagle Bridge. The fire started on a covered bridge across the Hudson River and was carried into the city by prevailing winds. Moses captured the frantic and futile efforts of a hastily summoned bucket brigade in the days before municipal fire departments existed.

Though a relatively small part of Grandma Moses' artistic output, the fantasy and historical paintings are important in that they allow the viewer to see how readily she could rework any subject in order to place it within her own artistic frame of reference.

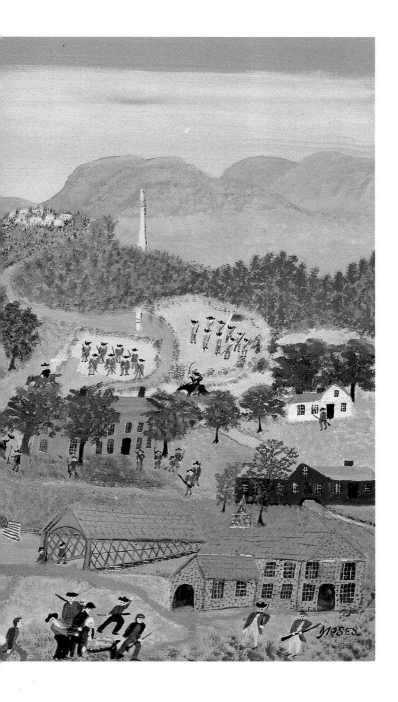

Eisenhower Home
1956; oil on pressed wood; 16 x 24 in. (40.6 x 61 cm).
Among Grandma Moses' most important artistic commissions was this one: a painting of President Eisenhower's well-known Pennsylvania farm retreat.

The Battle Of Bennington
1953; oil on pressed wood; 18 x 30 1/2 in. (46 x 76 cm).
The artist depicts the prelude to the skirmish with American troops assembling near the field of action. In the true, folk-art spirit, she incorporates the Bennington Battle Monument which was not erected until many years later.

Great Fire
1959; oil on pressed wood;
12 x 16 in. (30 x 41 cm).
One of Moses' most
dramatic works, this
painting depicts the
fire in a covered bridge
which, driven by high
winds, swept into the
city of Troy, New
York, destroying much
of that community.

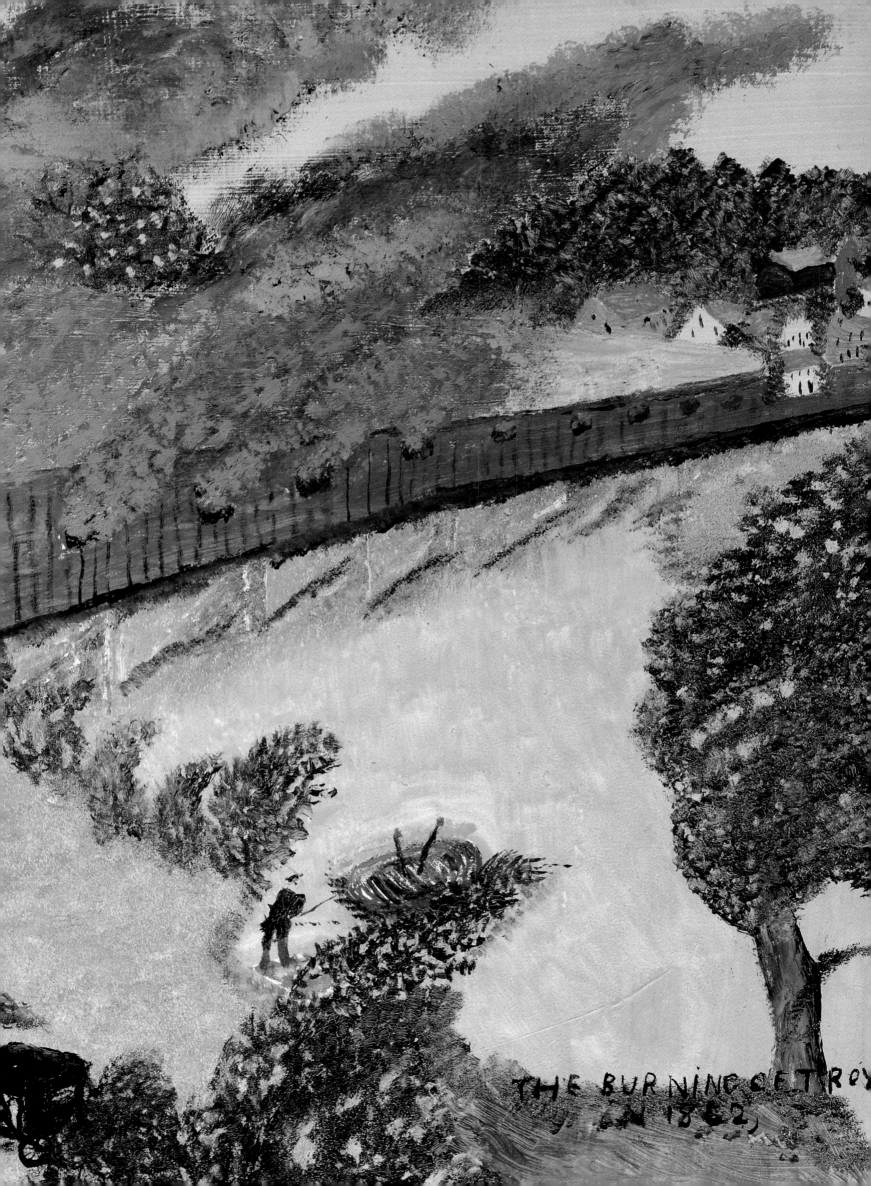

THE BURNING OF TROY
y AN 1862

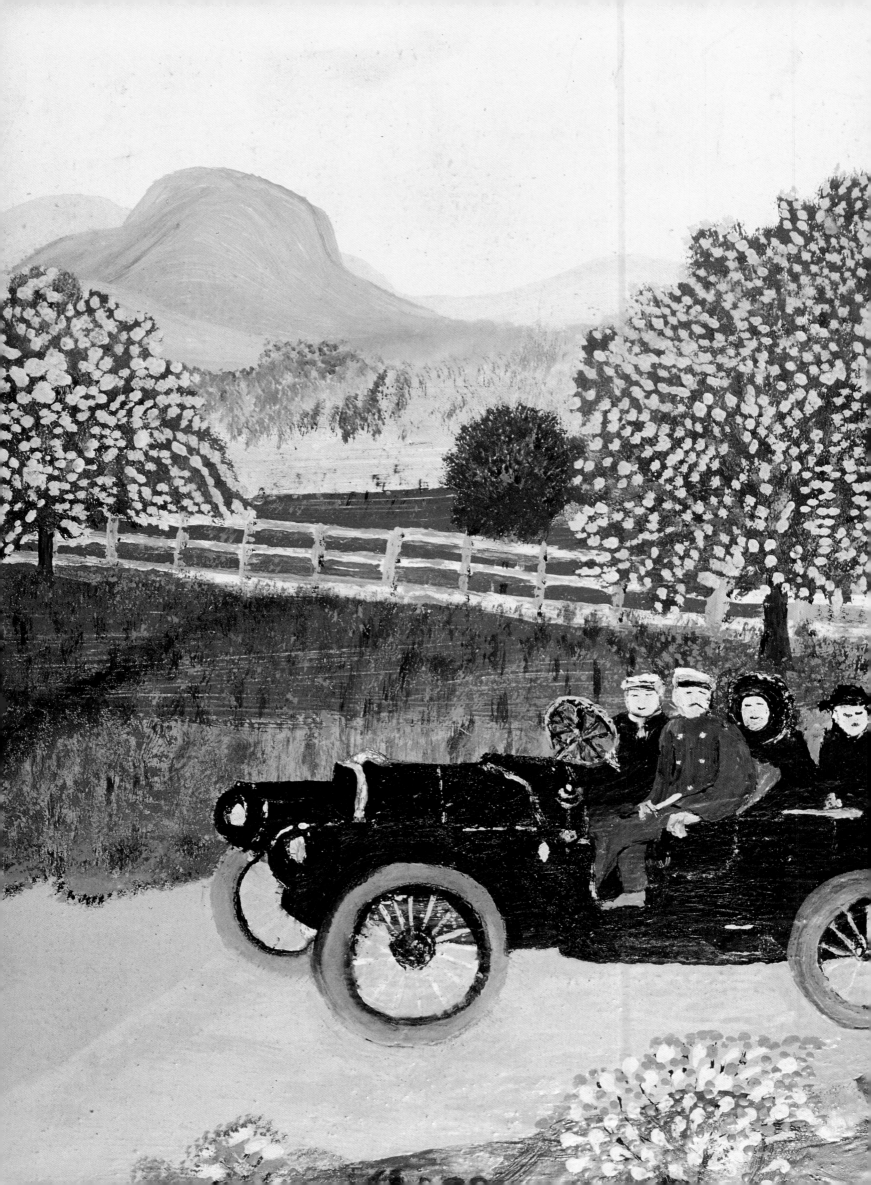

LIFE IMAGES: THE PERSONAL PAINTINGS

Many scenes painted by Grandma Moses are of personal and familiar surroundings, and even in such works as *Missouri* (1943), ostensibly set in another locale, the landscape, people, animals, and buildings are still clearly drawn from her life in upstate New York. There is, moreover, a small group of paintings that deal specifically with her personal history, particularly the houses in which she spent much of her life.

All the houses were colonial-style structures surrounded by barns and outbuildings; as rendered by the artist, they all look rather similar. In *The Childhood Home of Anna Mary Robertson Moses* (1942) she portrays the old house in Greenwich, New York, where she spent her early years. *Moses* (1953) shows the house in Eagle Bridge. Scenes of her youth can be imagined through *The Departure* (1951) which was possibly inspired by the day, November 9, 1887, when Anna Mary Robertson on her wedding day left for Virginia with her new husband, Thomas Salmon Moses.

The artist, who was often accused by her detractors of employing overly sentimental themes, showed little sentiment about what must have been a dramatic and wrenching moment, remarking only to Otto Kallir that "on the morning of the 9th of November I bid mother and father goodbye for the time, not knowing when I might see them again. We had to hurry over to take the six o'clock train to New York City."

The next painting in the series is *Belvedere 1890* (1942), in which the artist portrays the farm in Virginia on which she and Thomas

The First Automobile
c. 1939; oil on pressed wood; 9 3/4 x 11 1/2 in. (25 x 29 cm).
During her long life Grandma Moses saw many dramatic changes,
not the least of which was the coming of the automobile. This picture
is based on her first sighting of an auto, in Virginia soon after 1900.

lived for some years. While life in Virginia appears, at least in this painting, to have been bountiful, the Moses family eventually elected to return to New York. That moment is captured in *Moving Day* (1951), a work in which Moses manages to render the excitement and confusion of emptying a house without a trace of the anguish that inevitably accompanies such transitions, particularly in the case of farming families whose attachment to the soil is often as strong as to the home.

The farmhouse in Eagle Bridge, New York, which was Moses' home for over forty years appears in many of her pictures, and is specifically identified in the Mt. Nebo paintings. This name, which she applied to both the family's last home in Virginia and the new one in New York, is taken from a reference to a mountain in the Bible. Like other local landmarks the house is pictured in both summer and winter. *Mt. Nebo In Winter* (1943) captures the Hoosick River Valley nestled beneath a blanket of white, while the farm's inhabitants, as always amazingly active considering the weather conditions, scurry about on foot or rush off in horse-drawn sleighs.

The Departure

1951; oil on pressed wood;
17 x 22 in. (43 x 56 cm).
This painting was possibly inspired by a momentous event in the artist's life, the day in 1887 when, as a new bride, she left the family homestead for a new life on a Virginia farm.

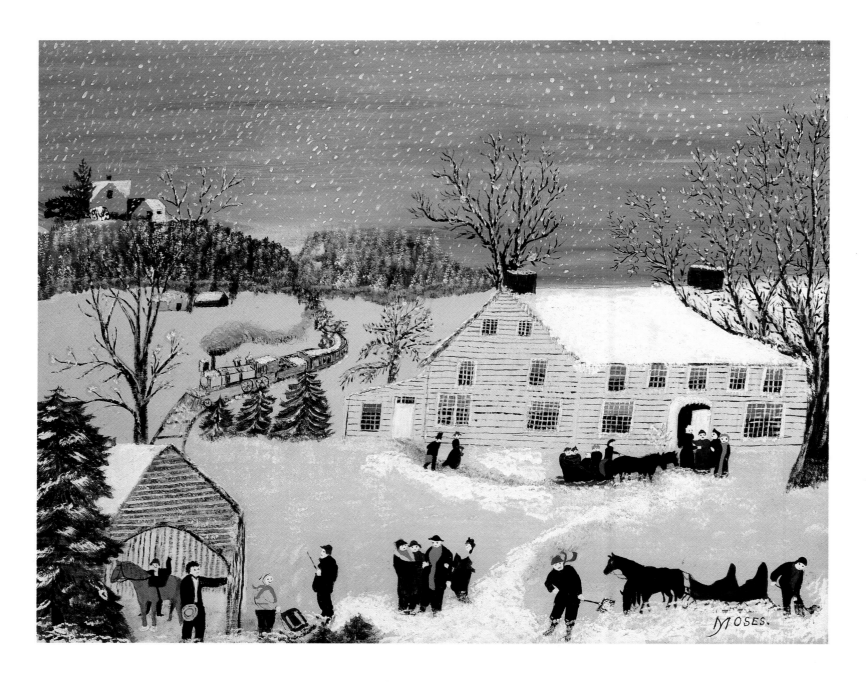

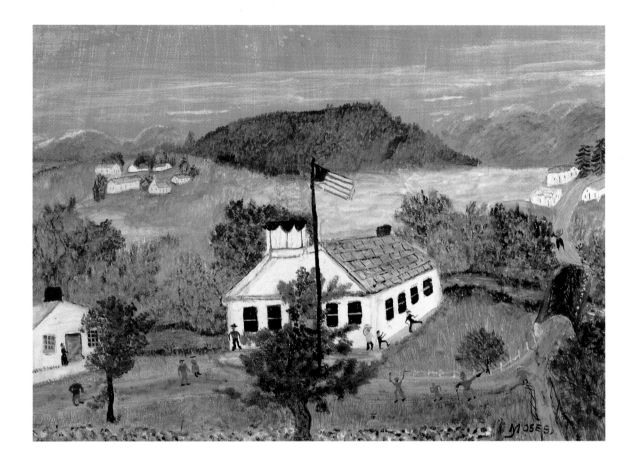

Eagle Bridge School

1959; oil on pressed wood;
12 x 16 in. (30 x 41 cm).
Yasuda Kasai Museum, Tokyo.
Grandma Moses had little
schooling, having been hired
out at an early age to work
for other families. Her brief
years in the traditional
one-room schoolhouse are
memorialized in this painting.

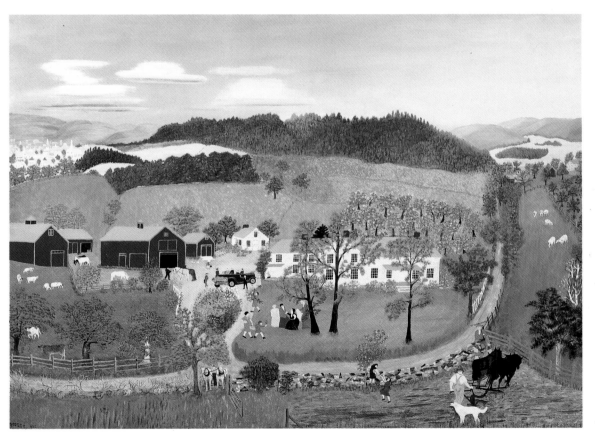

Grandma Going To The Big City

1946; oil on canvas;
36 x 48 in. (91 x 122 cm).
In a rare, direct, personal
reference, the artist depicts
her departure for New York
City and an event associated
with her artistic career.
Though generally willing
to do what was necessary to
advance her work, Grandma
preferred to stay at home.

Balloon

1957; oil on pressed wood;
15 7/8 x 24 in. (41 x 61 cm).
Grandma saw her first balloon
in 1907, and here she captures
the thrill of an event which must
have been as exciting in her day as
the first lunar landing was in ours.

The Moses homestead appears yet again in *Grandma Moses Going To Big City* (1946), a painting which is, in a sense, a somewhat radical departure from Grandma Moses' usual philosophy. While often featuring her home—and occasionally events in her life—in her work, she characteristically did not identify herself or her family members among the multitudes inhabiting her paintings. Yet here we find the artist in preparation for a trip to New York City (where her artistic career had taken her as early as 1940), holding court in front of the family manse while a great touring car is prepared for the journey. The scene is hardly typical of a woman who, despite her growing fame and fortune, remained generally modest and unassuming—a pleasant contrast to the air of self-importance adopted by some later twentieth-century artists.

Even in this painting not much is made of the great event. Children seem to be bringing offerings of flowers or flowering branches plucked from trees; a farmer plowing nearby remains oblivious to the scene. In

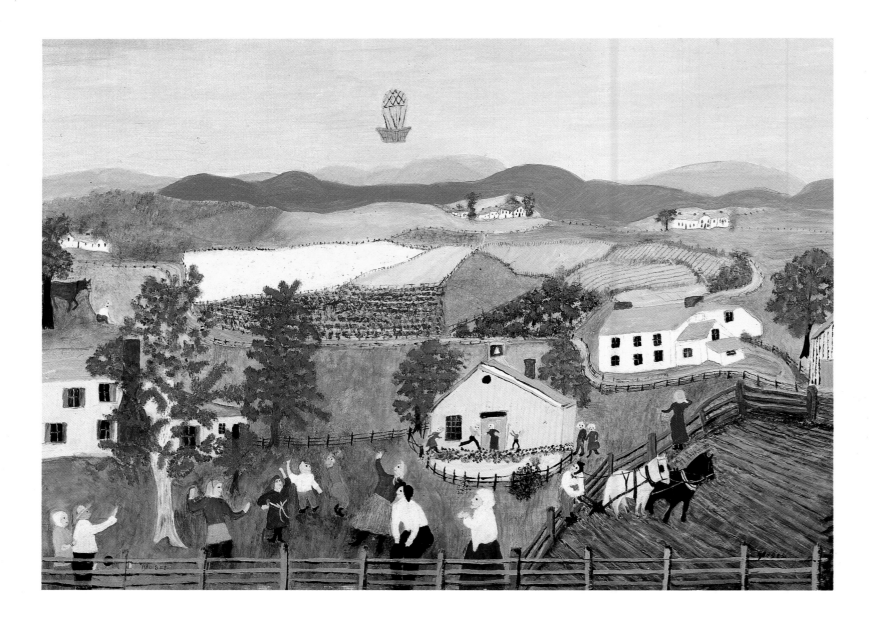

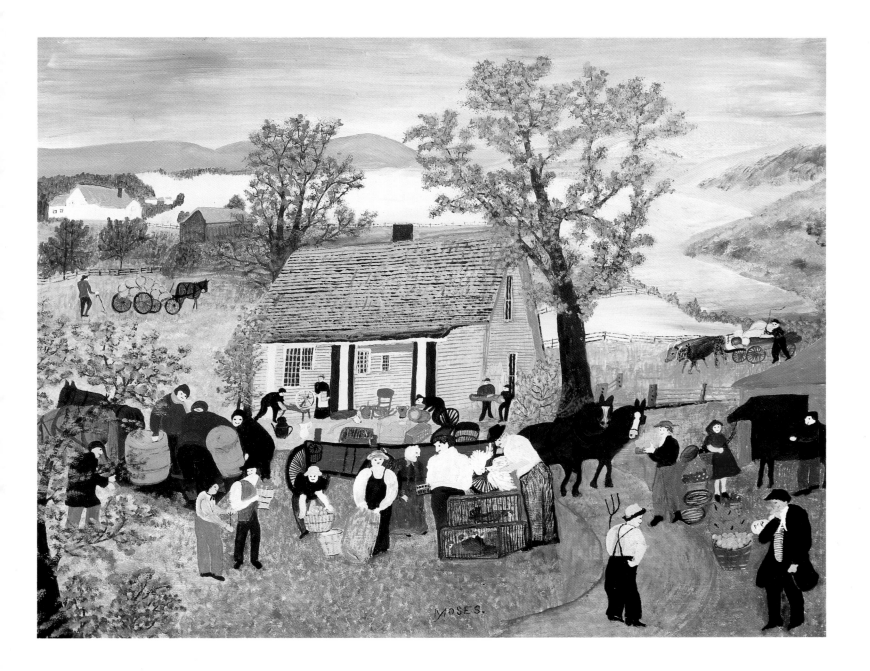

this picture Moses captured the character of the country folk, who were not easily impressed by the trappings of success but were more likely to show respect for healthy crops, large draft animals, or a cellar full of freshly canned produce.

This group of paintings, from *The Childhood Home of Anna Mary Robertson Moses* to *Grandma Moses Going To Big City*, provides us with what is in effect an illustrated autobiography of the artist. An interesting addition is *Year 1860—Year 1940* (1948), a painting in which Moses, fixing upon her birth as the year of beginning and 1940 (when she had her first Manhattan exhibition) as a terminal point, contrasts farming methods and equipment over an eighty-year span. While the change from horse and ox power to motorized tractors is self evident, the painting perhaps also defines Grandma Moses' involvement in agriculture. After 1940 she was an artist.

Moving Day on the Farm
1951; oil on pressed wood;
17 x 22 in. (43 x 56 cm).
In 1905 the Moses family returned to New York State after their sojourn in Virginia. Calling on this experience she was able to illustrate the bustle and confusion of a family packing up for the long trip home.

INDEX